IMAGES
of Rail

OCEAN SHORE RAILROAD

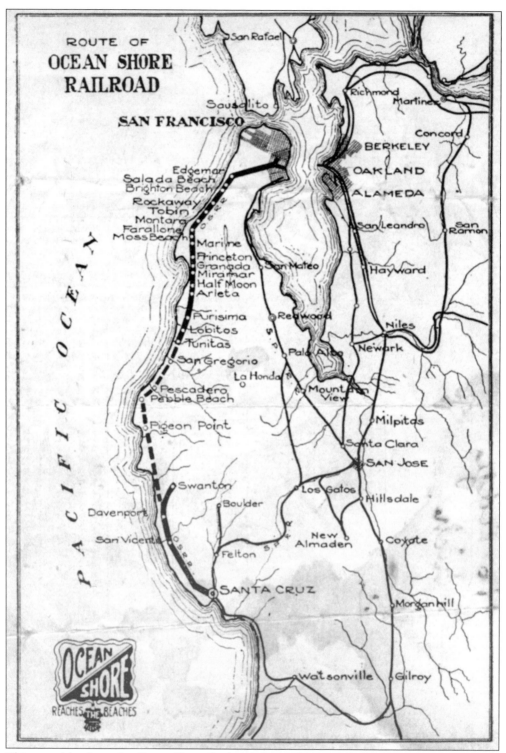

This pamphlet from the Ocean Shore Railroad shows the route from San Francisco to Santa Cruz, including the 28-mile "gap" between Tunitas and Swanton that was never filled.

IMAGES
of Rail

OCEAN SHORE
RAILROAD

Chris Hunter

ARCADIA

Published by Arcadia Publishing
Charleston SC, Chicago IL, Portsmouth NH, San Francisco CA

Printed in Great Britain

Library of Congress Catalog Card Number: 2004109962

For all general information contact Arcadia Publishing at:
Telephone 843-853-2070
Fax 843-853-0044
E-mail sales@arcadiapublishing.com
For customer service and orders:
Toll-Free 1-888-313-2665

Visit us on the internet at http://www.arcadiapublishing.com

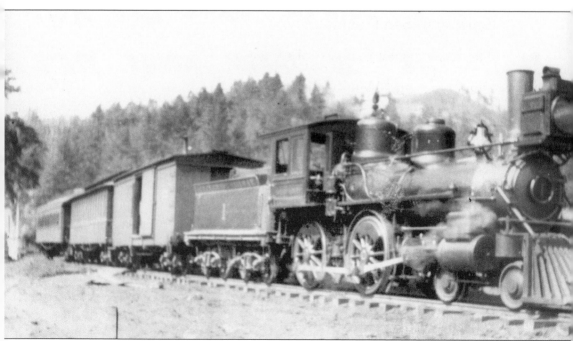

Engine No. 1 of the Ocean Shore Railroad goes on a run from Santa Cruz to Swanton, c. 1907.

CONTENTS

ACKNOWLEDGMENTS

Many people love the Ocean Shore Railroad for its historic qualities. Newspapers and magazines often focus on its brief life, repeating the same stories and republishing the same handful of iconic images. This compendium of information is no less an homage to what was the spirit of the Ocean Shore.

The amazing support and helpfulness of Danilo and Armando Vargas, twin brothers whose professional model building expertise led to their own infatuation with the Ocean Shore Railroad, helped make this book possible. The author thanks them for their good-natured support. It is through their good graces that the Ocean Shore collection of the late Ted Wurm as well as Will Whittaker's excellent photographs can be shared.

In some small way, this book is a tribute to Ted Wurm, whose father and mother both worked for the Ocean Shore Railroad and who became a railroad historian himself, writing other books about other railroads. He never got around to writing about the railroad that was the most personal to him, so this book is also for Ted, with enormous gratitude and respect.

Equally important is the photographic contribution of Will Whittaker, whose love of the Ocean Shore is only rivaled by the late Ted Wurm's. Others have spent decades keeping the memory of the Ocean Shore alive. John Schmale is not the least; his more than three-decade long love affair with the railroad encompasses a vast collection of information.

The Last Whistle is the king of Ocean Shore books. Jack Wagner's meticulously researched and documented history of the Ocean Shore Railroad, long out of print but still dominant in any discussion of the railroad's history, is owed a debt of gratitude for this and most other references to the Ocean Shore. Randolph Brandt's "Reaches the Beaches" pamphlet was also of invaluable assistance, filled with tidbits about locomotives geared for the *Western Railroader* magazine crowd. The extensive San Mateo County Historical Association and Museum's archives were extraordinarily helpful in providing details.

The Pacifica Historical Society, particularly the late Paul Azevedo and his wife Lydia, were extremely helpful in their support, providing access to clippings, videos, and photographs. Kathleen Manning, a co-president of the Pacifica Historical Society whose Prints Old and Rare store in Pacifica is a wonderland of historical memorabilia, was an enormous help in preparing this collection. Through Kathleen, the use of the Ocean Shore pictures of Jim Bell was made possible. Thanks also to Elizabeth Sor and the Pacifica Library. Hal and Barbara Ash of Ash's Vallemar Station restaurant still provide the public with an opportunity to enjoy a real Ocean Shore Railroad station, complete with photos and the models built by the Vargas brothers. The archives of the *Pacifica Tribune* also were enormously helpful.

The author apologizes for any slight or unintentional oversight created by an overzealous effort to capture the spirit of a bygone era. This book is an attempt to pay tribute to a little railroad that existed for a brief time in the early years of the 20th century. Perhaps the story will bring a smile to readers as it has to the author and so many others who love the Ocean Shore Railroad.

INTRODUCTION

There ought to be a song about the Ocean Shore Railroad. There should be a way to remember the near-mythic effort nearly 100 years ago to link the San Francisco peninsula's coastal areas to the twin cities of San Francisco and Santa Cruz, while in the process creating brand new cities.

The Ocean Shore Railroad didn't really work, and its effect on California is more conceptual, perhaps philosophical, than material, but the notion of it, linked to its short historical duration, deserves a song. It wasn't a catastrophe, like the "Wreck of the Edmund Fitzgerald," but it certainly should enjoy something in the spirit of a cross between "The City of New Orleans" and "Chattanooga Choo Choo."

The Ocean Shore Railroad adventure took place a century ago, but the unique images that bring back its memory are timeless. Perhaps that is because the cliffs and the ocean have hardly changed at all along the San Mateo County coast; only the growth of residential areas in Half Moon Bay and Pacifica has altered the landscape. The open land south to Santa Cruz looks much as it did when the Ocean Shore tracks paralleled the shore.

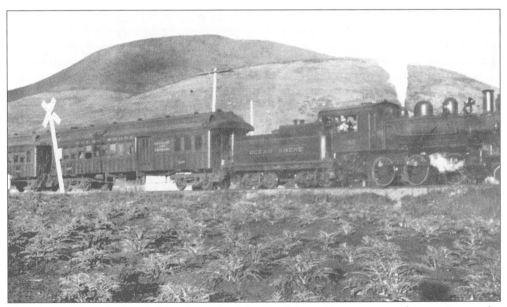

The Ocean Shore Railroad shaped much of the San Mateo County coastside, opening up the land and creating the potential for development. Here the train rambles through Rockaway Beach in present-day Pacifica.

The Ocean Shore Railroad had a life span of less than two decades, beginning in 1905 and ending in 1920. Those dates themselves are suspect, since they encompass the entire life of the actual railroad, from its birth as the Ocean Shore Railway to its death as the Ocean Shore Railroad. In truth, it was a working railroad for only a few of those years, the rest being consumed in construction, legal problems, and destruction.

And it only made money a few of the years it was in operation. However, from the moment investors imagined reaping huge profits from a railroad intended as a commuter's special, hauling passengers to and from the freshly minted suburbs serving San Francisco, to the day the tracks were torn up and sold as scrap metal, the dream never died. Only the reality of its own time and place, mixed with the progress and domination of the inexorable importance of the automobile, cut short its life.

But that dream . . . Even today people smile when they learn about the Ocean Shore Railroad. It wasn't a history-changing railroad with a golden spike meeting in the middle of the continent. It wasn't a transportation legend that opened up the West or the North or the South. It wasn't the tourist trains of Henry Flagler that brought prosperity and people to south Florida.

No, the Ocean Shore Railroad offers something different than almost all other train stories. It has been called a magnificent failure, an idea before its time, and an amazingly foolhardy undertaking. It could inspire a terrific song, but the pictures in this book will have to do for now.

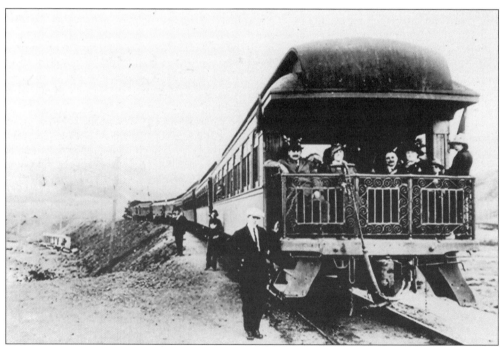

Perhaps one of the most reproduced images relating to the Ocean Shore Railroad, this photograph from the Will Whittaker collection shows a young boy and the train near Green Canyon. The train brought sightseers and families to the coastside.

One

A COASTSIDE DREAM

San Francisco in the 1800s, much as it is in the 2000s, was the dominant metropolitan area for Northern California. Think back to 1849 and the discovery of gold, then jump to the dot-com boom of the 1990s. The importance of San Francisco as a financial hub, cultural capital, and influential city is remarkable.

Sitting on the tip of the San Francisco peninsula, the city has always looked south, north, and east for its suburbs. Even as those areas blossomed into cities in their own right, San Francisco's influence continued. San Jose to the south, anchoring the lower part of the San Francisco Bay, has only recently surpassed San Francisco in population, but it will probably never rival the northern city in prestige or popularity.

Back in the days when San Francisco was the most significant city west of the Mississippi, its domain encompassed just about all of the land on the peninsula, all the way south to San Jose. However, it maintained a clustered and dense boundary, leaving itself congested while much of the peninsula remained a holiday resort for the wealthy. The mansions of Hillsborough, Woodside, and Atherton began as holiday homes for San Francisco's elite.

OCEAN SHORE RAILWAY
✦ COMPANY. ✦
Ⓧ First Mortgage Five Per Cent Sinking Fund Thirty Year Gold Bond ✦

Ocean Shore Railway Company, a corporation created and existing under and by virtue of the laws of the State of California, for value received hereby

Serious efforts to create a railway that would serve the coastline began in 1905. J. Downey Harvey was the mastermind. He was joined by J.A. Folger, whose family had already established a coffee empire, and Horace D. Pillsbury of the prominent law firm of Pillsbury, Madison and Scott. These men were intent on bringing to life a modern, rapid transit dream. On May 18 of that year, they incorporated and the Ocean Shore Railway came into conceptual existence.

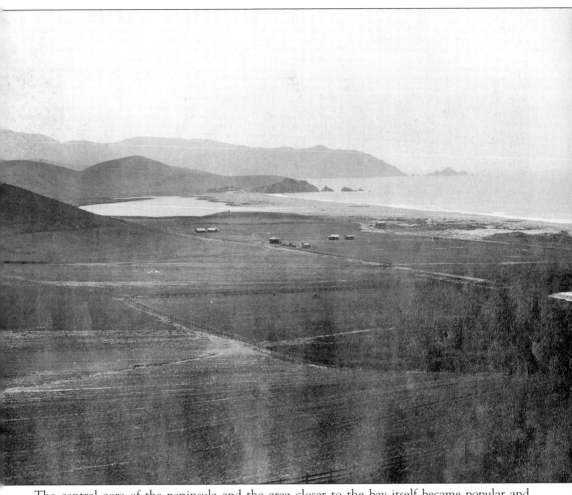

The central core of the peninsula and the area closer to the bay itself became popular and accessible. People reaching their homes in Belmont or San Mateo could count on train service, as in other parts of the country, because the population was healthy enough to warrant the service. A San Francisco/San Jose railroad, for example, was no more unusual an undertaking than trains serving the Boston area. It made sense and offered financial rewards. San Francisco was full of both money and visionary businessmen. The combination seemed a perfect match for a new venture, based on the solid expectations of a continued boom in population and prosperity. Looking south along the peninsula's vast and desolate coastline, these entrepreneurs saw a new kind of gold mine. It wasn't a new idea; bonds were actually sold in the late 1800s for a "San Francisco Ocean Shore Railway." In a prospectus published in 1881, developers predicted much of what the future Ocean Shore would actually promise.

Every convenience of city life will be provided for guests in a similar manner to the hotels and pavilions now at Coney Island and Long Branch in the vicinity of New York. It is carefully estimated that inasmuch as traffic will continue all year round instead of for a few weeks, as at Coney Island and Long Branch, that at least 1,000,000 passengers will pass over this portion of the road at an expense of 50¢ for the round trip, that at least $500,000 per annum will be earned from passengers alone of this first 16 miles, in addition to which the local rates to San Pedro, and between San Pedro, Spanish Town, Pescadero, and Santa Cruz, will add largely to the above amount, at least an additional $200,000.

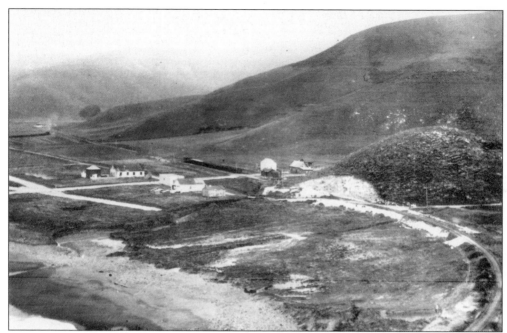

Rockaway Beach, like the other Long Island–inspired names for towns along the San Mateo County coastside, was isolated and inaccessible in the early part of the 20th century. The initial effort to create the Ocean Shore Railway, as it was first called, included extensive plans to build a double-track electric railway from San Francisco to Santa Cruz. The cuts made into the hills through Rockaway and Vallemar became the Highway 1 cuts, eventually allowing automobile access.

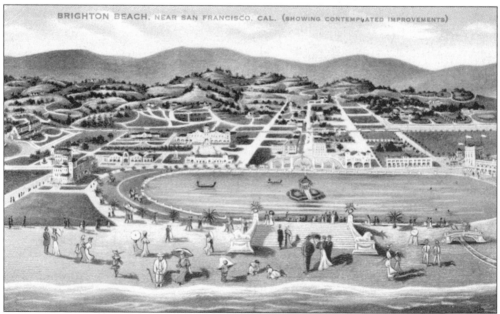

BRIGHTON BEACH, NEAR SAN FRANCISCO, CAL. (SHOWING CONTEMPLATED IMPROVEMENTS)

Brighton Beach, one of the developments launched by the Ocean Shore Railroad, included plans for a magnificent recreational water site. The Laguna Salada is now part of the Sharp Park Golf Course. The resort never materialized.

12

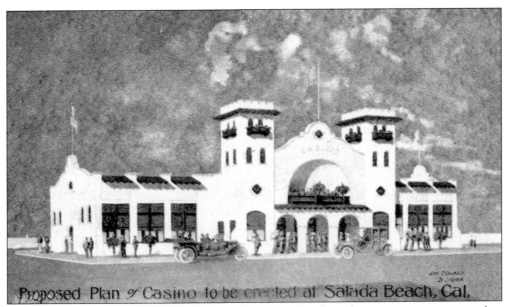

Proposed Plan of Casino to be erected at Salada Beach, Cal.

The developers of the Salada Beach Casino envisioned a flourishing resort environment less than 20 miles from downtown San Francisco. Again, while the dreams were big, they were never realized beyond this postcard stage.

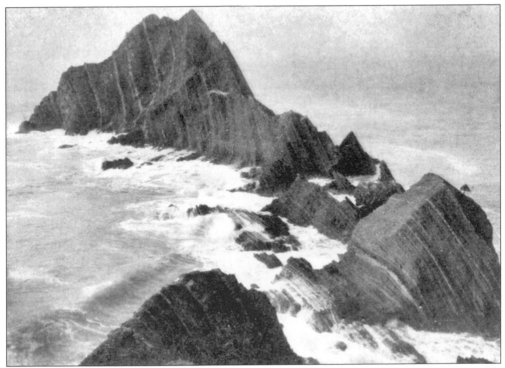

The majestic rocks at San Pedro Point are perhaps one of the area's most recognizable formations. Unchanged through the ages, they have maintained their picturesque allure.

The barren sand dunes and open fields of Sharp Park were a contrast to the hustle and bustle of San Francisco.

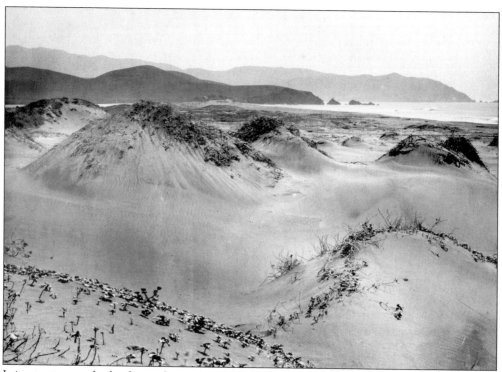

It is easy to see why land speculators dreamed of suburban homes along the spacious coast.

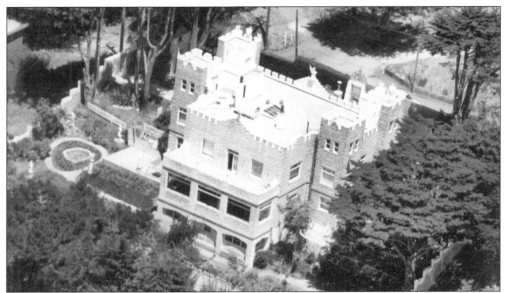

One of only a handful of manmade structures along the coast when the Ocean Shore Railway was first created, the castle in present-day Pacifica was built in 1908 following the 1906 earthquake in San Francisco. Henry Harrison McCloskey, an attorney for the Ocean Shore Railway, built the poured-concrete replica of a Scottish castle and called it "Bendemier." It was sold following his death in 1914. McCloskey's grandson Pete became a U.S. congressman, representing San Mateo County. The castle had a long and storied history, serving as everything from a mysterious clinic for illegal abortions to housing for the U.S. Coast Guard during World War II. In 1962 it was purchased by Sam Mazza on a whim for about $29,000 to serve as a repository for Sam's eclectic collection of art and memorabilia. Following his death, a trust was set up to administer the property. The castle still looks out over the coastline much as it did when the Ocean Shore trains rambled by. Today, travelers in cars glance up at the mysterious building with probably the same curiosity as those long ago train passengers.

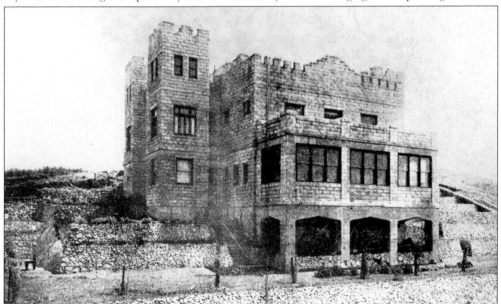

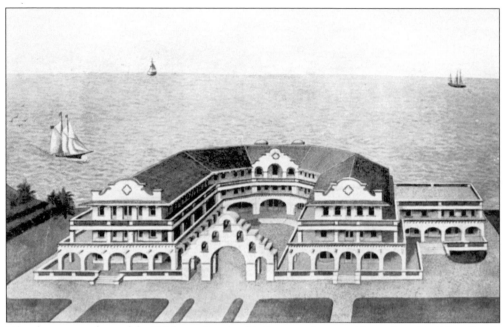

Like the resorts planned for Brighton Beach, this fantasy of a magnificent hotel in Moss Beach was counting on the growth of "San Francisco's Seaside Suburb."

Fields of artichokes dominated much of the coastal valleys, adding to the possibility that the Ocean Shore Railway could become an important produce transporter.

Two

STARTING IN
SAN FRANCISCO

The great city of San Francisco has always lured adventurers and entrepreneurs—people who saw a need and wanted to meet that need. Looking west to the mostly uninhabited lands along the coastal shores of the peninsula, they saw the potential for another gold rush. But first, they had to overcome the challenge of creating a brand new railway system through an already bustling metropolitan city.

It is said that backroom deals and a few shady arrangements helped move the project forward. Corruption would have been nothing new in the San Francisco of 1905, a time when Mayor Eugene E. Schmitz spent a great deal of time denying any wrongdoing, even after his felony conviction for bribery. Nonetheless, the franchises to lay new track from the eastern edge of the city out to the coast were granted and plans were in place for a grand opening in 1907.

Similar, though less complex, franchises were granted in the City of Santa Cruz. But in that southern terminus, it turned out that competing railroad companies were not thrilled, or supportive, of a new line. The Southern Pacific threw a spur line across the Ocean Shore's route, creating a headache that never really went away. Other lines were built to compete for cement, lumber, and produce business, pinching much of the financial hopes placed in the Ocean Shore.

Still, in many ways, the beginnings of the Ocean Shore Electric Railway seemed clever and calculated, with every chance of success.

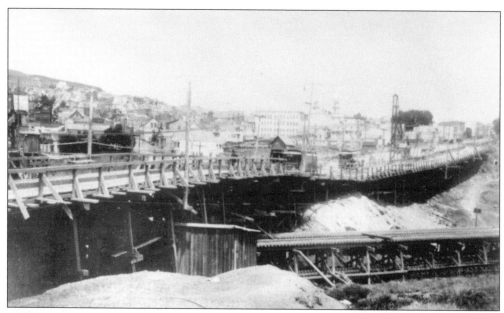

Snaking out from the City of San Francisco, the Ocean Shore Railway line followed the path of Alemany Boulevard. In the above photograph, it passes under the new Mission Street viaduct, c. 1912.

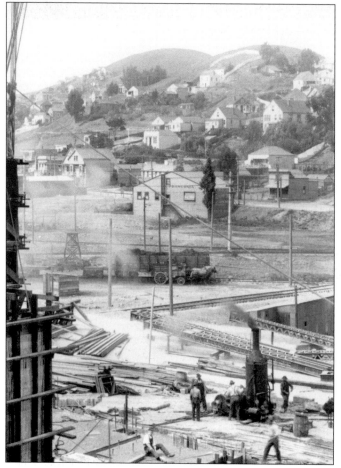

The San Francisco railroad yards near Army and Kansas Streets, c. 1912, were busy with rail traffic and hopes for more growth.

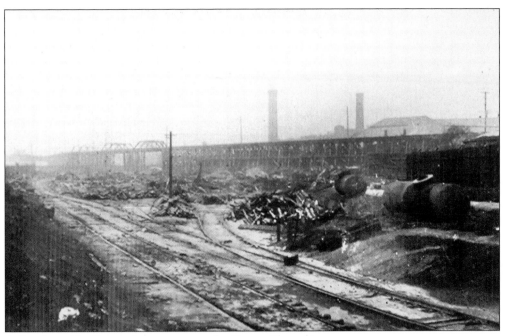

A Southern Pacific trestle crosses over the Ocean Shore lines.

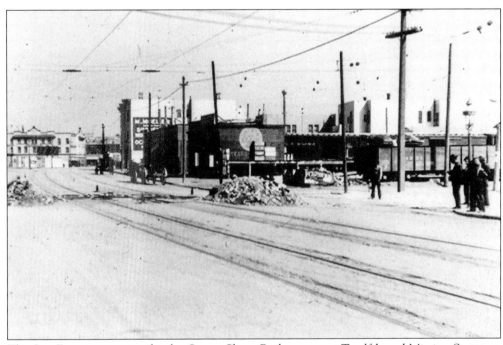

The San Francisco station for the Ocean Shore Railway was at Twelfth and Mission Streets.

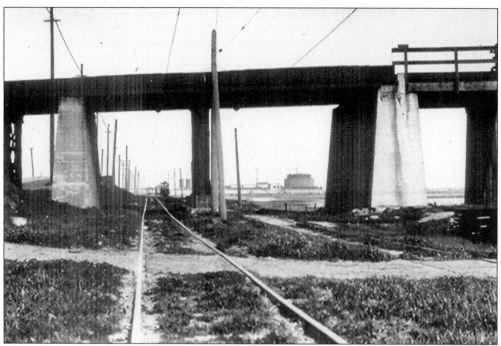

This photograph shows the Ocean Shore track as it passed beneath the Army Street overpass.

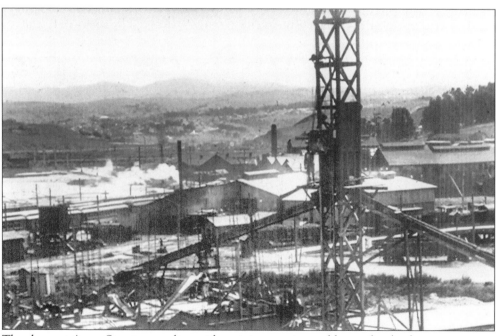

The shops at Army Street were alive with activity, repairs, and hopes for the future.

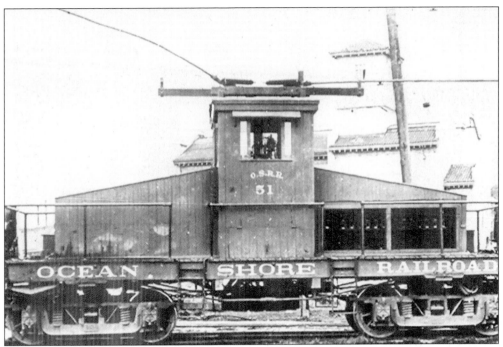

This unusual-looking Ocean Shore Railroad electric locomotive No. 51 was built in the Army Street shops. While the initial dream of a thriving railroad industry serving the coast was not altogether far-fetched, obstacles as varied as earthquakes, union strikes, and the lack of on-time payment for railroad cars helped doom the transportation effort. Throughout its brief career, the Ocean Shore seemed almost cursed. Larger railroad companies such as the Southern Pacific seemed to plot against the Ocean Shore by crossing its tracks near Santa Cruz and other areas. A "mysterious" railroad company placed parallel tracks from Santa Cruz to Davenport, taking away the lucrative lumber and concrete business. Of course, it was actually Southern Pacific.

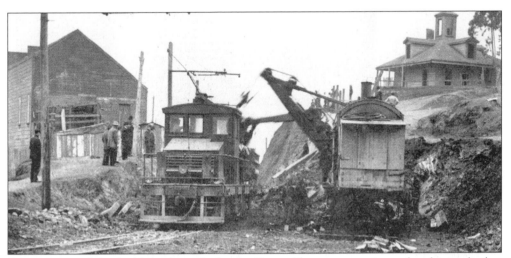

Construction of the double-wide tracks for the Ocean Shore was a major undertaking, whether on oceanside cliffs or through San Francisco, as in this picture, which shows an even further widening for a San Francisco local line.

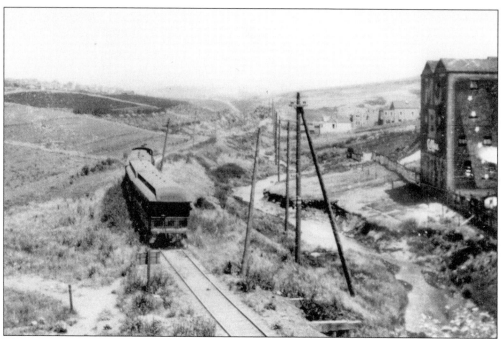

The passengers on the Ocean Shore happily left San Francisco along Alemany Boulevard. Present-day BART (Bay Area Rapid Transit) does much the same thing.

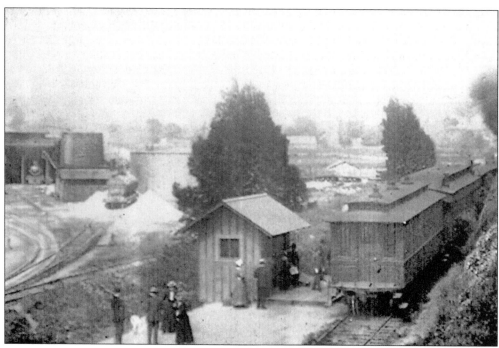

The tiny station reserved for the Ocean Shore in Santa Cruz was proof that the railroad gods were working overtime against the company. Original plans called for a grand station, but the Southern Pacific prevented the Ocean Shore from reaching that goal.

Three
THE EARTHQUAKE CATASTROPHE

The Ocean Shore Railway was all set to make its dazzling debut when nature decided its fate instead. Construction projects that were remarkable feats of engineering in and of themselves were already linking the Ocean Shore through San Francisco, out through the suburbs of Daly City, and all the way to the Pacific Ocean at Mussel Rock, where a picturesque ledge had been carved out of the rock and the true beginning of the scenic railway was evident.

But on April 18, 1906, the San Andreas Fault shifted. The City of San Francisco endured the brunt of the massive earth movement, with fires causing catastrophic damage, but it must be noted that the San Andreas Fault meets the ocean at essentially the location where the Ocean Shore did the same thing. The fury of the earthquake dropped much of the rolling stock into the ocean and destroyed most of the coastal work that had been done up to that point.

It would have been easy to give up, but the Ocean Shore wasn't ready to call it quits. Yet. Within a short time after the earthquake, the little railroad had made up for lost time and was hoping to recoup its investment. That possibility had also been shaken, but not forsaken.

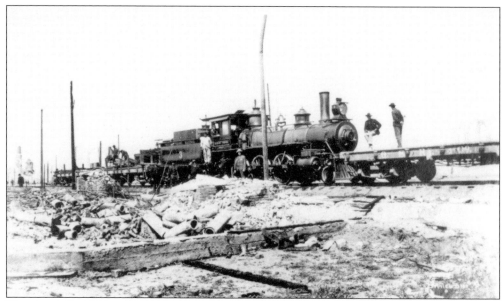

The April 18, 1906 earthquake all but destroyed the Ocean Shore Railway, dropping much of its rolling stock into the Pacific Ocean at Mussel Rock. The little railroad helped out by hauling debris from the city. A Herculean effort to rebuild and continue with the plan enabled the Ocean Shore to "reach the beaches," but San Franciscans were intent on rebuilding their city, not moving out. Three years after the earthquake, in 1909, the Ocean Shore Railway was bankrupt. The next phase of the Ocean Shore included reincorporation as the Ocean Shore Railroad.

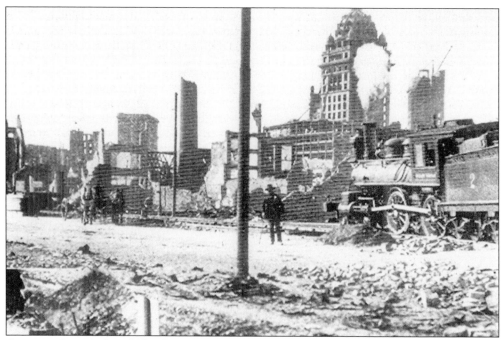

Creeping through the rubble of San Francisco, the remains of the Ocean Shore company helped as best it could while struggling to rebuild along the coast.

24

Four

DIGGING IN AND DEVIL'S SLIDE

The idea that in 1905 engineers would look at the craggy, picturesque coast along northern San Mateo County and imagine a railroad hugging the cliffs is as remarkable today as it must have been then. The vision, of course, involved the age-old development philosophy of providing access to a lovely location; the result would be riches for land speculators and homes for people seeking to live in a beautiful place. Most of the time, this combination has proven successful.

Using dynamite and steam shovels, the Ocean Shore Railway construction crews forged a path through and around some of the most treacherous territory in California. Building a ledge along a cliff face was simple compared to blowing massive cuts into hillsides and carving tunnels in the rock walls. Wooden trestles gracefully arched over canyons and valleys, contrasting with raised berms and the relatively flat stretches south of Pedro Point.

At Devil's Slide, the reality of the problem, an ongoing headache that continues to plague transportation into the 21st century, was faced head on. (A $300 million double-bore tunnel to bypass Devil's Slide is in the works.) The Ocean Shore bored a tunnel through the western edge of San Pedro Mountain and then, almost magically, carved a ledge hundreds of feet high across the sheer face of the cliffs. At Devil's Slide the railroad essentially had to snake across a geological element that would always be in danger of slipping. And slip it did, sliding from above and below depending on rain, movement, or just timing.

When the construction through Pedro Point and the Devil's Slide area was complete, Ocean Shore officials trumpeted that the worst was over and it would be smooth sailing south to Santa Cruz.

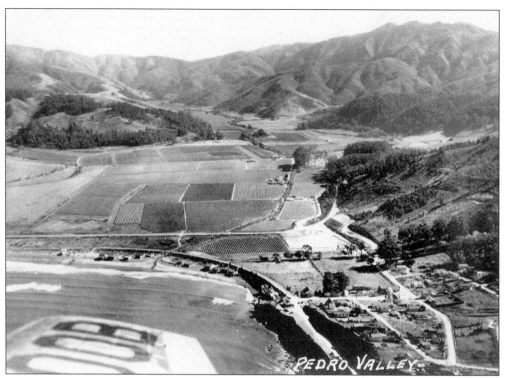

This aerial view of Linda Mar and Pedro Point shows the path of the Ocean Shore along the beach leading up to the resort known as Shelter Cove.

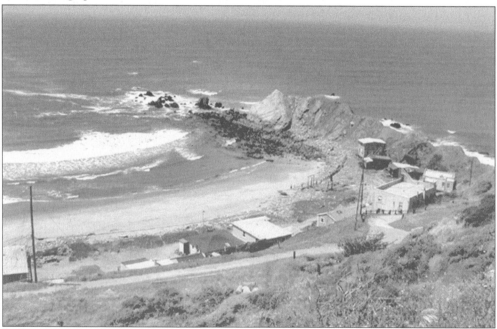

Today Shelter Cove is a private residential area inaccessible by car because of a collapsed roadway that once was the Ocean Shore right-of-way. A tunnel was bored beyond Shelter Cove, enabling the Ocean Shore to wind around the corner of San Pedro Mountain.

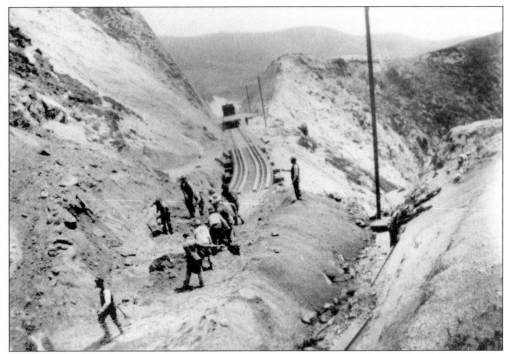

Digging and blasting small mountains of earth to make way for the Ocean Shore was a tedious and dangerous task. Originally, at least seven tunnels were planned, but it was decided blowing cuts into the barriers would be cheaper and ultimately safer. Only the 400-foot tunnel through the western point of San Pedro Mountain was bored. The rest, like this cut being excavated, were created by blasting out rock by the ton. Most of the cuts created by the Ocean Shore Railroad workers became essential pathways through the hills for the eventual Highway 1, also known as the Cabrillo Highway or the Pacific Coast Highway. Nine tons of dynamite blew apart the massive Saddle Cut south of Devil's Slide.

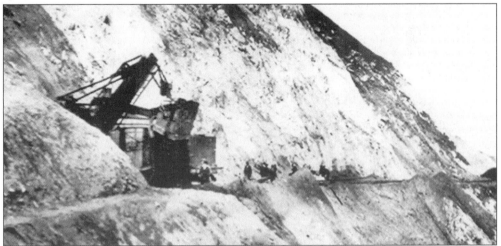

Reconfigured as the Ocean Shore Railroad in 1911, the company gave up its plan for a double-track electric transportation system and worked hard to establish a more conventional railroad down the coast. The cliffs and hills of present-day Pacifica leading to the Devil's Slide area were the biggest challenges.

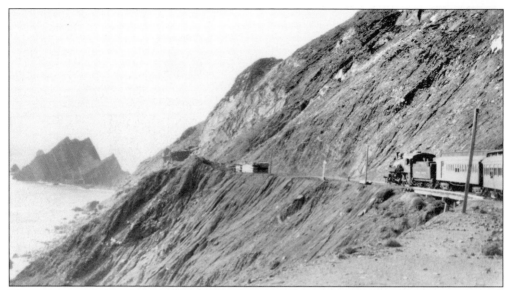

The most remarkable engineering feat was the creation of the Pedro Mountain tunnel, which cut through the western corner of the steep cliffs of the mountain, connecting present-day Pacifica with points south. This picture shows an Ocean Shore train heading north toward the tunnel. The Point San Pedro Rocks are visible to the left. The Ransome Company, a small rock quarry company, perched precariously near the entrance, benefited from the removal of rock.

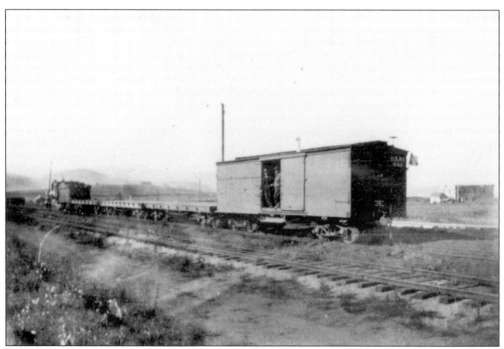

It seemed as though the Ocean Shore was the only real activity along the coast, giving investors the belief that a railroad would create a housing and economic boom for the San Mateo County coast.

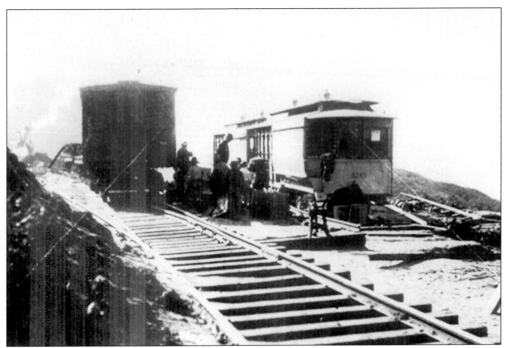
Construction on the railroad involved tedious, dangerous, and difficult tasks, such as shaping ledges out of rocky shelves.

Railroad crews worked hard to carve out the Ocean Shore path.

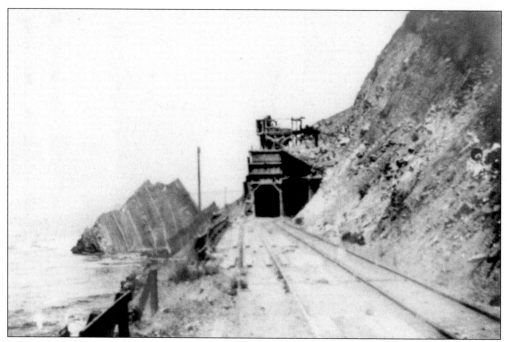

It is possible in this picture to see just how delicate the hold on the side of the mountain the Ransome Quarry maintained. This angle of the southern end of the Pedro Point tunnel provided a marvelous view of the San Pedro Rocks.

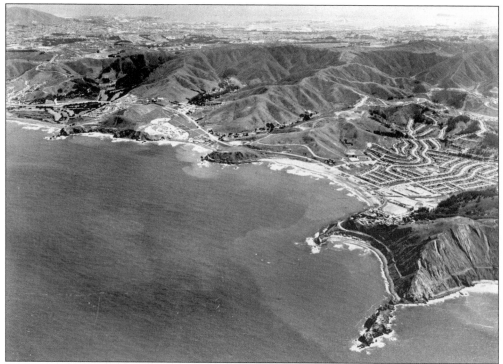

This aerial photograph clearly shows the path of the Ocean Shore as it hugs the coast and reaches Pedro Point, where the ledge is clearly visible.

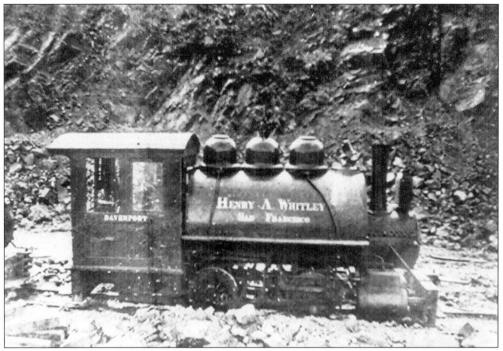

This tough little engine was one of the powerful trains used in the construction phase of the Ocean Shore line. Capable of hauling tremendous loads, it was leased during the project.

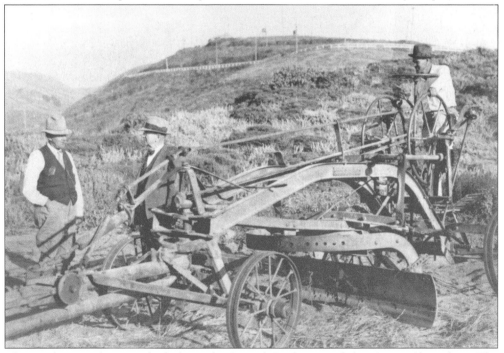

This grading machine worked along the Mussel Rock area of the Ocean Shore line. The photograph represents a later effort, perhaps in 1935, to regrade an unused roadbed. Ocean Shore chief engineer Frank J. Oakley is pictured in the center.

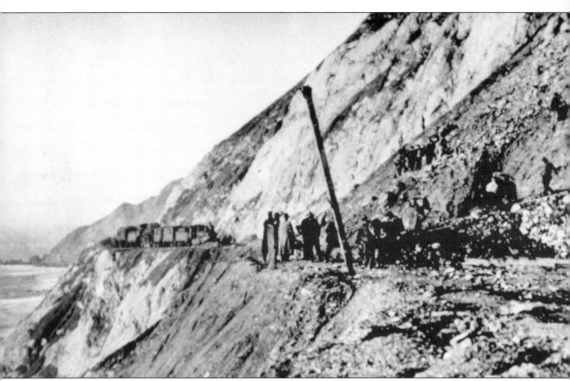

The most difficult part of the Ocean Shore was clearly Devil's Slide. The train would have to wait whenever a landslide closed part of the path along a ledge. The problem still exists for cars traveling on Highway 1 today.

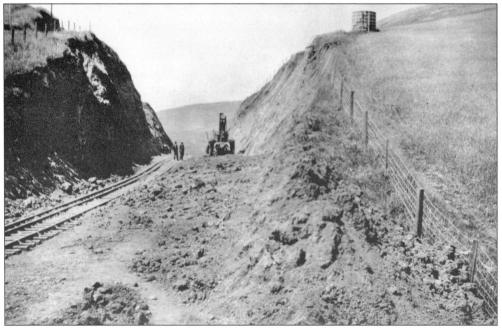

Originally intending to make many small tunnels through obstacles, Ocean Shore engineers wound up making cuts that today serve as openings for Highway 1 traffic.

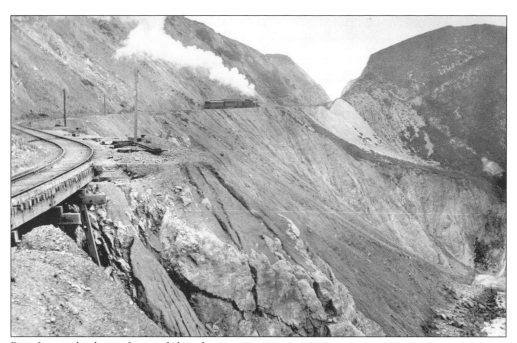

Reinforcing bridgework to stabilize the tracks was an amazing engineering feat back in 1908. The Ocean Shore Railroad managed to figure out a way to get trains across a landscape that seemed totally impassable. Because it was a relatively short span compared to the entire length of the railroad's projected distance from San Francisco to Santa Cruz, the work along Devil's Slide and the Pedro Point tunnel seemed the most daunting, yet upon completion, it enabled the company to boast that the rest of the way would be so much easier. The reality turned out to be quite different.

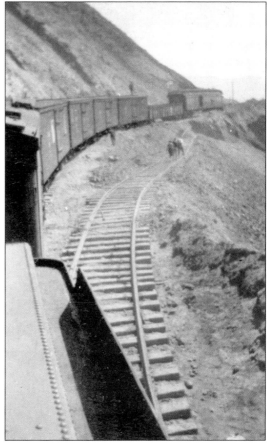

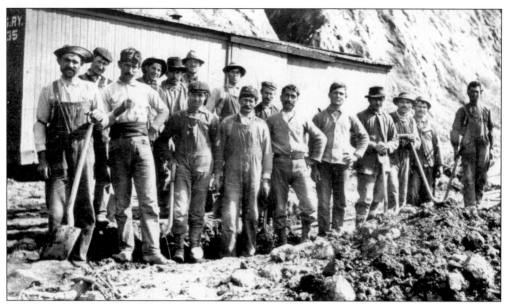

Greek railroad gangs worked tirelessly to excavate the Pedro Point tunnel and carve out the Devil's Slide ledges upon which the train would travel.

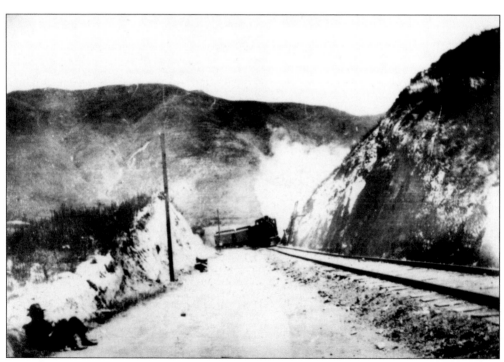

Here the train comes through a cut near Green Canyon. Note the man seated at left.

34

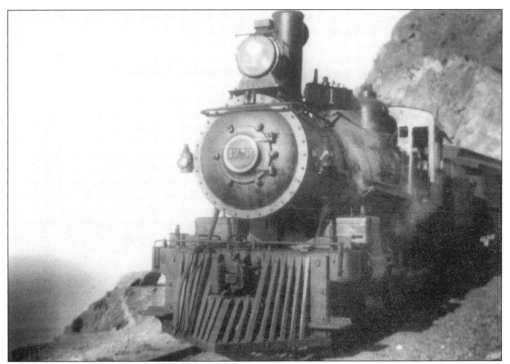

Called the *Mermaid Special*, this train was one of the very first runs along the completed Devil's Slide ledge. Marketers for the Ocean Shore Railroad took delight in linking every aspect of the commercial enterprise with wistful images and allusions to the ocean.

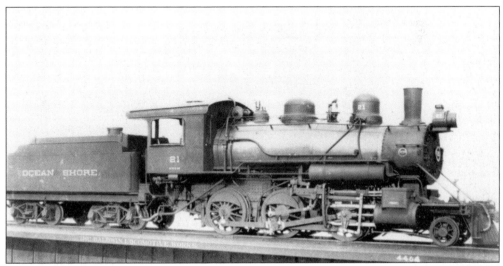

This builder's photo of Ocean Shore No. 21, purchased in 1913, shows one of the heaviest and most powerful engines used by the railroad.

Devil's Slide was an appropriately named obstacle to the Ocean Shore Railroad and an ongoing challenge to transportation throughout the 20th century. Landslides from above and collapsing roadway below plagued the area for more than 100 years. Caltrans will begin the process of building a $300 million twin-bore auto tunnel through San Pedro Mountain in 2004. Movement of the road is monitored by sophisticated technical equipment.

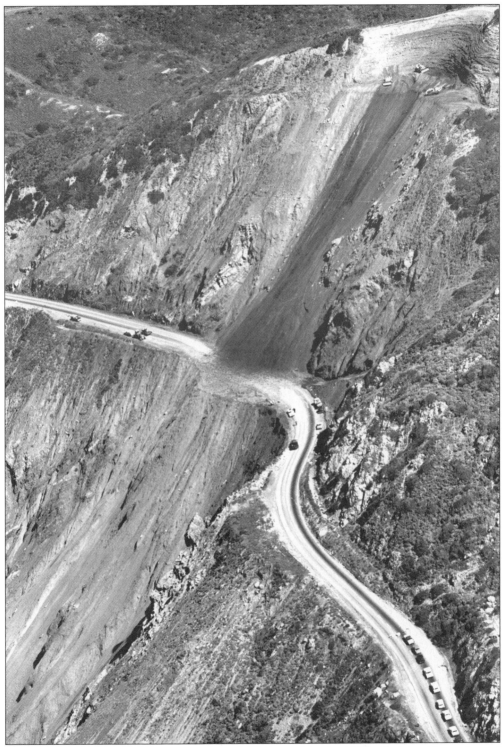

This aerial view shows a slide cutting through Highway 1 in the 1960s. Such problems plagued the Ocean Shore Railroad and continue to threaten automobile traffic to this day.

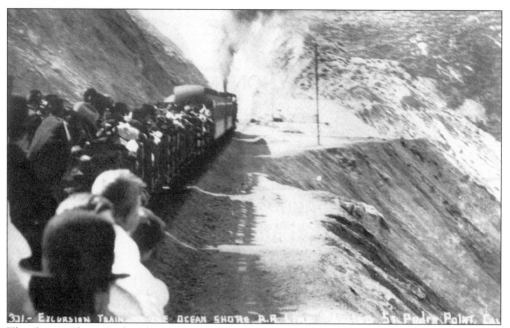

The Ocean Shore Railroad was extraordinarily popular for a brief period, with folks piling on the trains for weekend excursions.

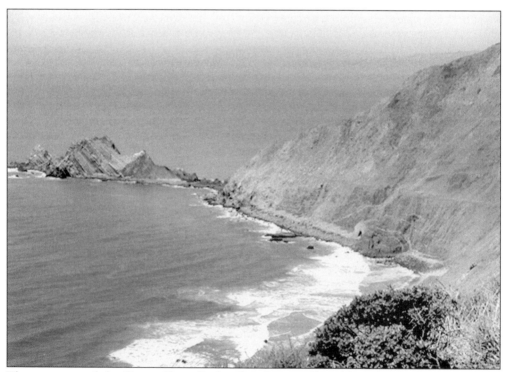

The remnants of the Ocean Shore Railroad path are still visible today south of San Pedro Point Rocks.

Five

COMMUTING ALONG THE COASTSIDE

The open expanse of land along the San Mateo County coast seemed perfect for a boom in population once it was easily accessible thanks to regular commuter service along the Ocean Shore Railroad. The plan did not change after the bankruptcy of the Ocean Shore Railway in 1909 and investors continued to believe that the earlier failure was not the result of a lack of interest but a poor business plan.

With the line complete except for a 28-mile "gap" between Tunitas and Swanton, the Ocean Shore Railroad worked at attracting new business and new residents. The plan would never work unless a "critical mass" of people could be developed.

Folks who already lived along the coast were delighted at the opportunity to reach San Francisco or Santa Cruz, but new residents, lured to destinations like Pedro Valley or the hoped-for oasis called Granada, never materialized in sufficient numbers to boost the finances.

The tremendous amount of marketing and advertising that flooded San Francisco newspapers at the time is a testament to the ambitious plans of the railroad and the developers. A major land developer itself, the railroad bought up property along the route and hoped to carve it into suburbs full of new riders.

Alas, while it is obvious that a ride on the Ocean Shore was comparable to the most exciting theme park attraction of today, the bustling suburbs never materialized. Today Pacifica, the city that owes much of its existence to the early Ocean Shore efforts, has 40,000 residents spread out through the various hamlets mostly created by those early marketing efforts. And most of them are commuters—by car—to jobs elsewhere.

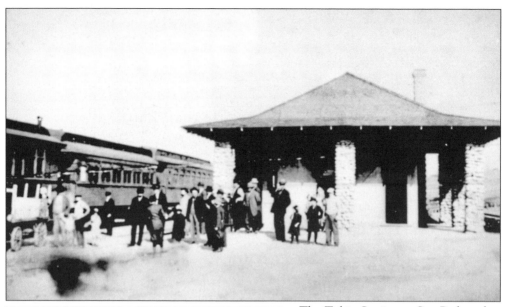

The Tobin Station at San Pedro, also known as San Pedro Terrace, was an important stop for the new Ocean Shore Railroad, offering spectacular views and the enticing San Pedro Beach, now Pacifica State Beach.

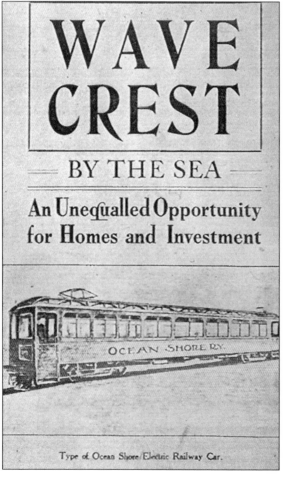

WAVE CREST

— BY THE SEA —

An Unequalled Opportunity for Homes and Investment

Type of Ocean Shore Electric Railway Car.

Marketing pamphlets like this one promoted the coast as a great place to live. The term "Wavecrest" remains in the name of a contemporary Half Moon Bay development project.

WHERE ARE YOU GOING SUNDAY?

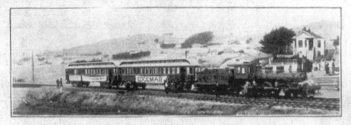

FIRST PASSENGER TRAIN ON OCEAN SHORE RAILROAD TO EDGEMAR

The first train on the Ocean Shore Railroad arrived at EDGEMAR at 11:52 on Tuesday, October 1st, after a run of 17½ minutes from Ocean View. One hundred and twenty-five passengers and the officials of the railroad were aboard. The passengers were surprised and delighted with the wonderful beauty of the road along the great bluffs at Mussel Rock where the breakers roll and flash their turbulent line of white hundreds of feet below. The first stop was made at

EDGEMAR
THE NEAREST SEASIDE SUBURB

Take this ride and see for yourself. You will enjoy the day, see the wonders of this new road, and appreciate the beauties of EDGEMAR, as a place for a home and the possibilities there for profitable investment. Come prepared to be convinced, for EDGEMAR will win you. It is the first station, the first beach, has a beauty all its own, and is being handled in a high class distinctive way. Good building restrictions, all improvements actually being put in now at our expense, hundreds of people who really desire something a little different and better have already bought there and are building homes, and the prices are within the reach of all. Come and see it at our expense. Apply for transportation, direct or by phone at the home office, or at any of the branch offices.

EDGEMAR REALTY SYNDICATE
═══ OWNERS ═══

2055 SUTTER STREET
PHONE WEST 3152

BRANCH OFFICES · C. D. YOUNG & CO.
735 VAN NESS AVENUE
ROGERS, YOUNG & CO.
2330 MISSION STREET

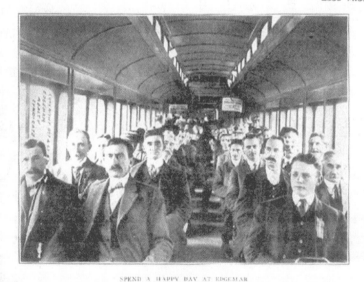

SPEND A HAPPY DAY AT EDGEMAR

Whether commuting into the city from a home at the beach or just day-tripping, the Ocean Shore Railroad wanted to be all things to all coastsiders.

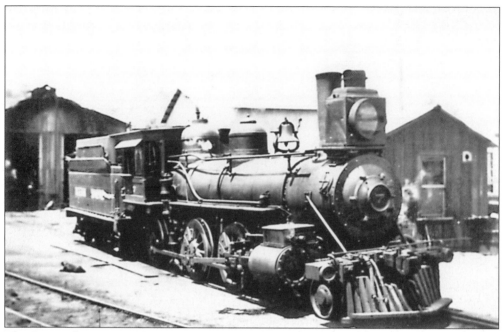

The Ocean Shore's No. 7 locomotive is pictured here c. 1907.

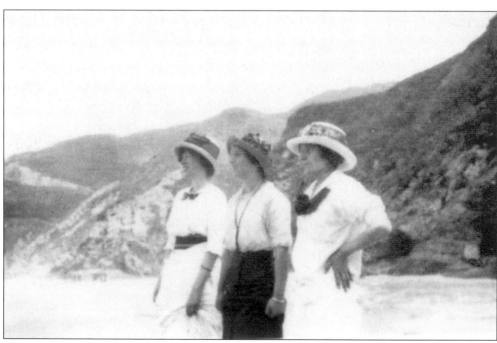

These ladies were typical of the sightseers who boarded the Ocean Shore to reach the beach. In this case, they're near Montara, south of Devil's Slide.

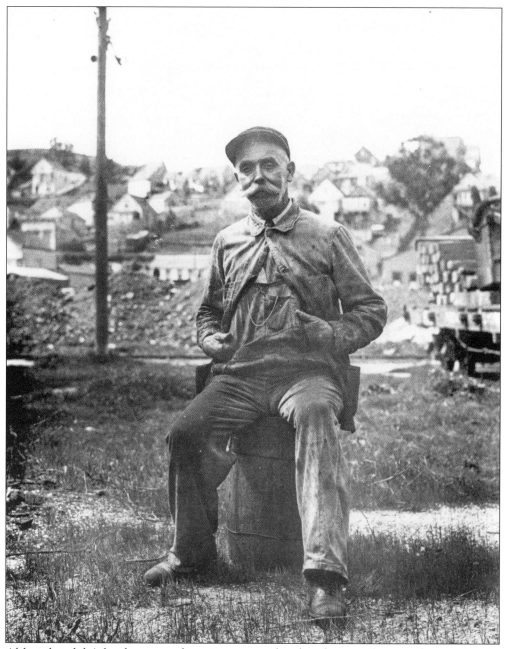

Although it didn't last long enough to give many railroad workers a real career, there were quite a few who spent more than 10 years with the company. This is John Jackson, an Alemany Station engineer, *c.* 1915.

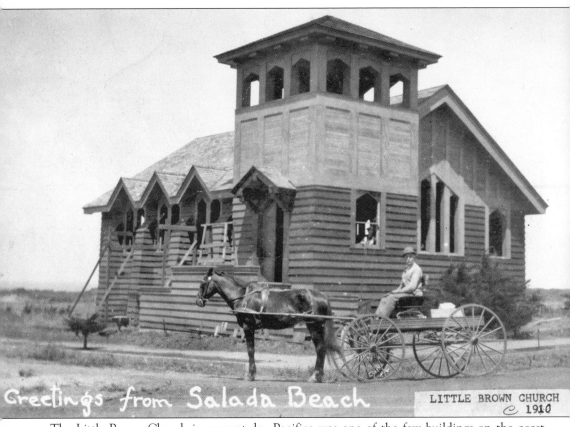

Greetings from Salada Beach

The Little Brown Church in present-day Pacifica was one of the few buildings on the coast when the Ocean Shore Railroad chugged by. Constructed in 1910, the little building has seen its share of history and is now in the midst of a preservation effort by the Pacifica Historical Society.

The entire line has an unparalleled scenery of mountain, ocean, valley and plateau, with an ever-changing panorama of seaside attractions.

—Ocean Shore marketing ad copy

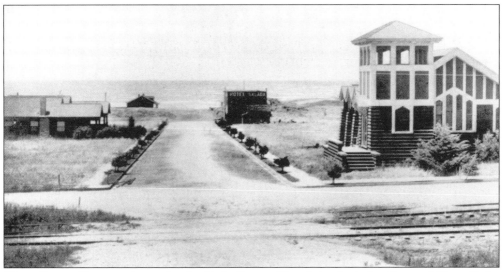

These Ocean Shore tracks run by the Little Brown Church in the isolated area of Sharp Park.

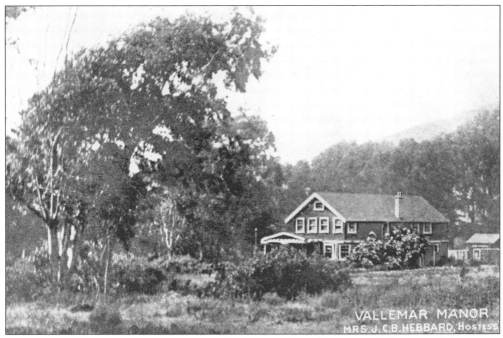

This lodge in Vallemar was another one of the few existing businesses at the time of the Ocean Shore Railroad.

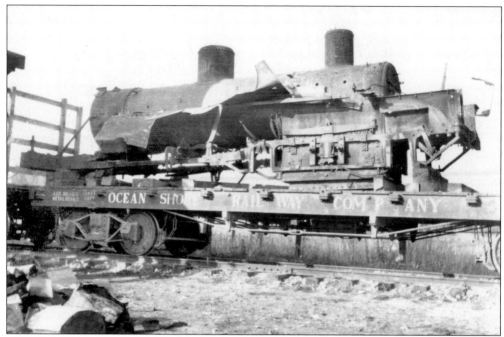

This Ocean Shore engine is being carried back to the yards in an effort to discover why it dropped its crown sheet. The curled metal coming off the engine can be seen sitting on the Ocean Shore flat car.

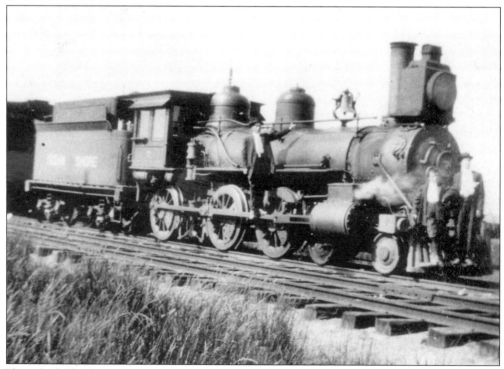

If you look closely, you can see the smiles of pride on these three fellows clinging to the Ocean Shore engine.

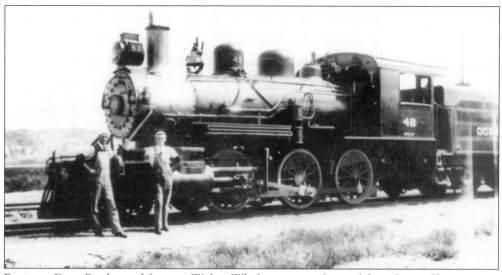

Engineer Dave Parsley and fireman Walter Whalem pose in front of their Ocean Shore engine in this *c.* 1917 picture.

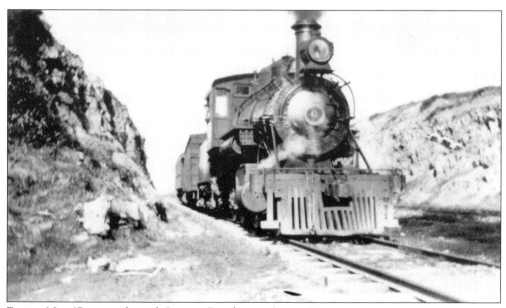

Engine No. 67 passes through Laguna Beach near Santa Cruz.

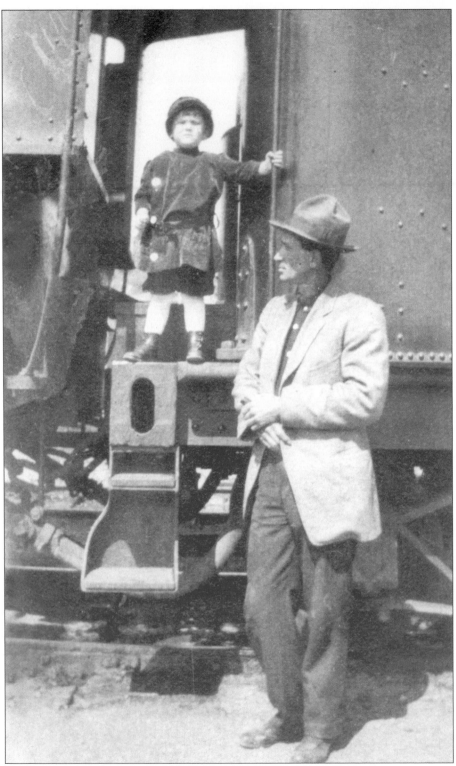

Peggy Sharp poses with an unidentified man—possibly her father.

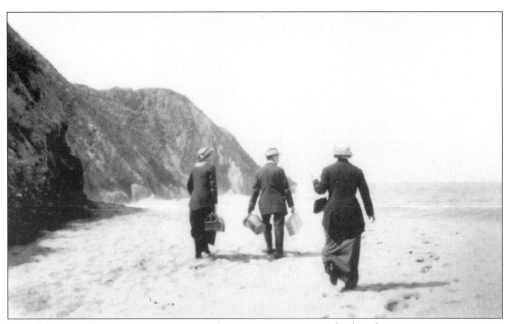

Travelers came from San Francisco on the train to picnic on the beach.

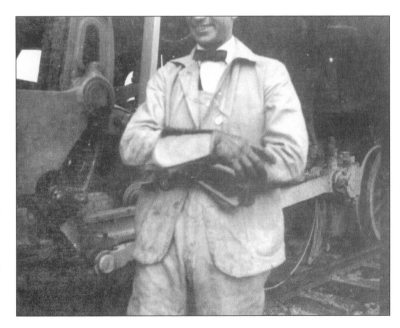

Although the original photograph seems to have focused on Engineer Dave Parsley's gloves, the photographer did keep Parsley's big grin in the picture.

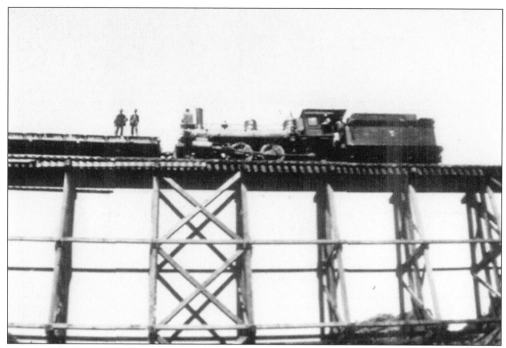

Trestles were a major element of the Ocean Shore Railroad, bridging canyons and creeks up and down the line. The remarkable wooden trestles dotted the landscape and one can only imagine how they quivered when the engines thundered across them.

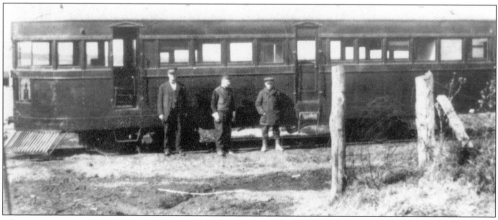

This was a typical passenger car used by the Ocean Shore Railroad.

Oceans around the world are a draw for tourists, and the Pacific Ocean, reached by way of the Ocean Shore Railroad, was no different.

Salada Beach was hardly anything when the Ocean Shore arrived to build up its image.

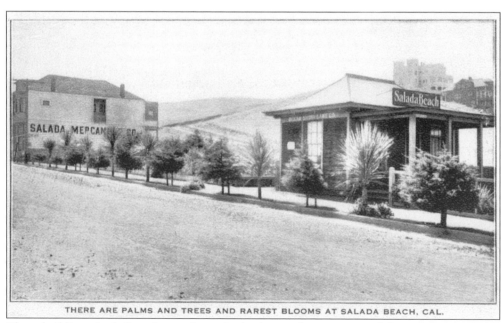

THERE ARE PALMS AND TREES AND RAREST BLOOMS AT SALADA BEACH, CAL.

These buildings, including the castle in the background, were some of the only structures in Salada Beach in the mid-1910s.

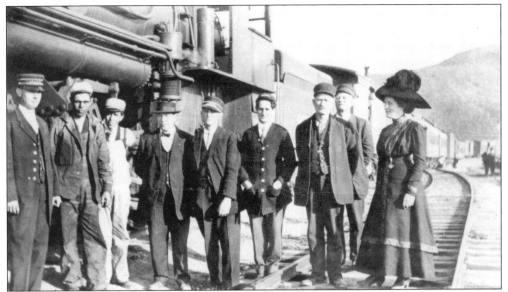

It was hoped that commuters and tourists would flock to the shore, as they did in Long Island, New York.

Point San Pedro, near Half Moon Bay

9/13/07

This 1907 postcard depicts the area south of Devil's Slide, eventually reached by the Ocean Shore Railroad.

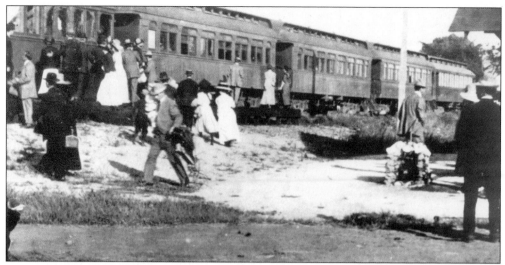

For a brief period the enthusiasm of the marketing teams was actually matched by the people living in San Francisco and along the coast. Land speculation fueled hopes for high returns on investment, and those who already lived along the coast were delighted to have access to the city. In reality, there turned out to be too few tourists and commuters to make the business successful in the long run.

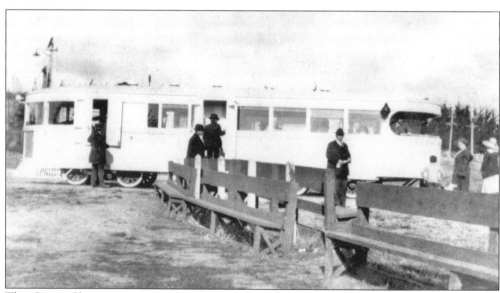

The Ocean Shore experimented with a variety of engines and railroad systems. Originally intended to be all electric, the railroad turned to steam following the 1906 earthquake. Later it brought on gasoline-powered engines, hoping to bring down transportation costs and lure back passengers.

The Railroad Commission, in a decision rendered yesterday, refused to order the Ocean Shore Railroad to continue the summer trains during the winter season on the ground that the continuance of the special service would not yield a sufficient revenue to warrant it. Patrons of the road petitioned the commission to enforce the continuance of the special trains. There is no question but that a modern service would prove of great service to the Ocean Shore Railroad. There are many attractive places along the line for suburban homes and resorts. Thousands of people have purchased property along the line with the intention of building homes. Real estate operators were promised an elaborate electric service by the original promoters of the road who sold a large amount of property to home seekers on such a promise.

—San Francisco Chronicle, December 6, 1912

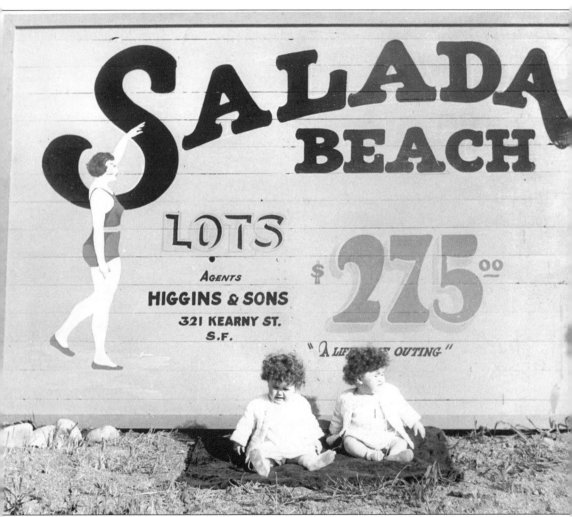

Land speculation was probably the most significant business connection to the Ocean Shore Railroad. There was even an Ocean Shore Land Company. Much was spent on a steady stream of advertising campaigns to convince people that a home along the coast could be possible thanks to the Ocean Shore Railroad.

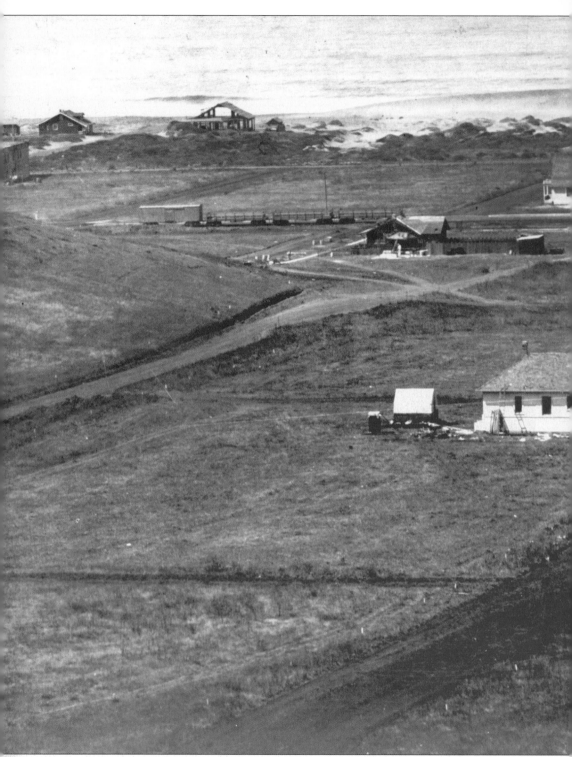

In this dramatic photograph the Ocean Shore Railroad passes through Salada Beach, with the ocean on one side and vast potential for development on the other side. Being so close to San

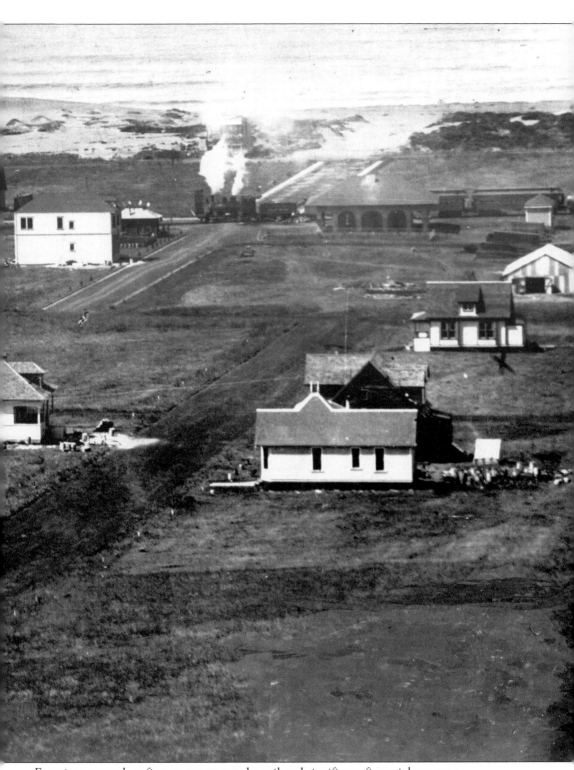

Francisco seemed, at first, to guarantee the railroad significant financial success.

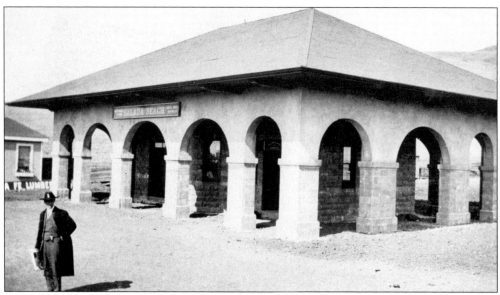

The Salada Beach Station seems a substantial edifice, but it did not live up to the dreams many had for the area.

Small cottages such as these were promoted as inexpensive vacation homes along the Ocean Shore route. The tiny 25-foot wide lots created at the time have caused planning and zoning headaches for present-day cities such as Pacifica.

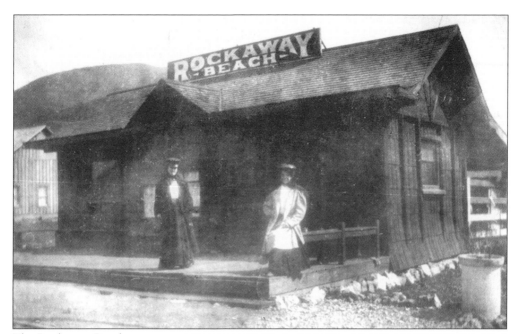

The Rockaway Beach Station, unlike the Vallemar Station, disappeared altogether. Its location is basically now the intersection of Highway 1 and Rockaway Beach Avenue. An anecdote notes that the train had to back up to Vallemar after picking up Rockaway passengers in order to pick up enough speed to make it up the incline leading to the Rockaway Point ledge.

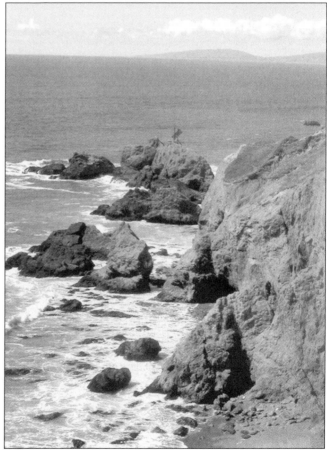

The natural beauty of places like the Mussel Rock area remains as untouched as it was during the time of the Ocean Shore.

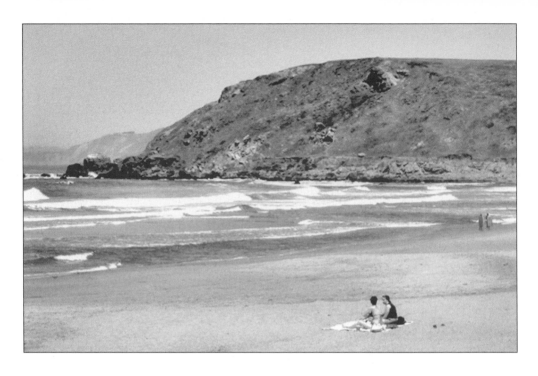

The Ocean Shore carved a ledge around the Rockaway headlands that is still visible today. Erosion has removed most of it, but beachgoers are still amazed to see the remnants of the railroad path clinging to the ridge.

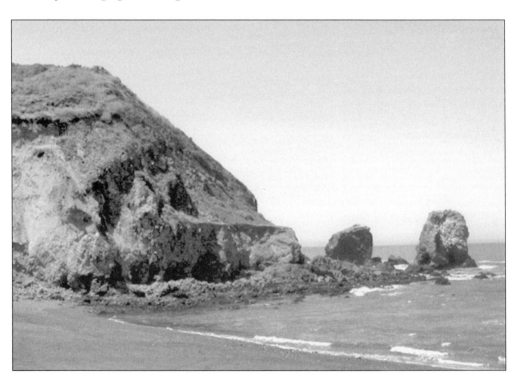

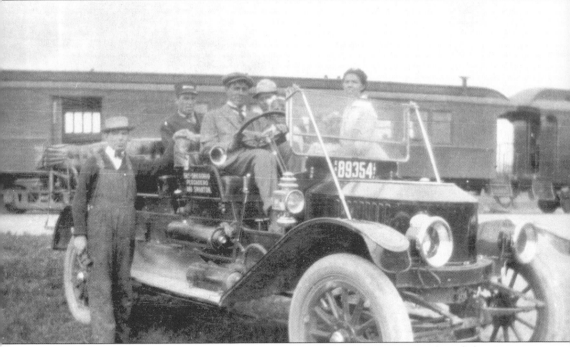

The 28-mile "gap" between Tunitas and Swanton was never filled with track and the Ocean Shore Railroad became an automobile service between the two ends of the system.

Officers of the Ocean Shore Railroad have taken preliminary steps for filling in the gap between Tunitas and Smith Cove, a distance of 28 miles, thereby opening to traffic the Ocean Shore line from San Francisco to Santa Cruz. The effectiveness of the plan will depend upon the Railroad Commission's approval of a transaction whereby the Ocean Shore seeks to bond itself for sufficient money to build an immediate 10-mile extension from Tunitas to the heart of a rich timber belt, much of the property on which has recently changed hands.

—San Francisco Chronicle, December 26, 1912

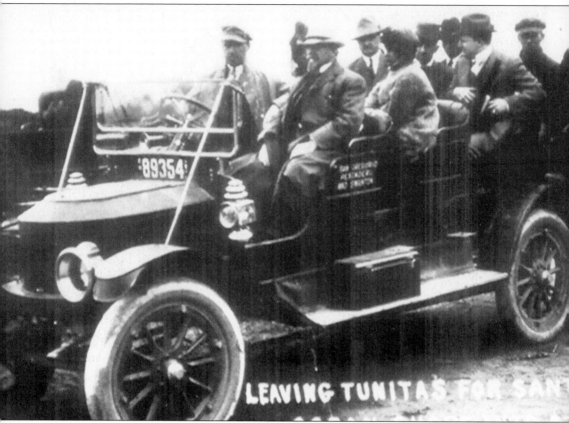

LEAVING TUNITAS FOR SAN

The Ocean Shore Railroad tried to make a go of the auto service, but it obviously was a major drawback to promoting the railroad as an easy way to get from San Francisco to Santa Cruz. Eventually, other rail lines through the peninsula made it easier and the "gap" wound up becoming the dominant mode of transportation as cars could eventually make the coastal trip without any railroad assistance.

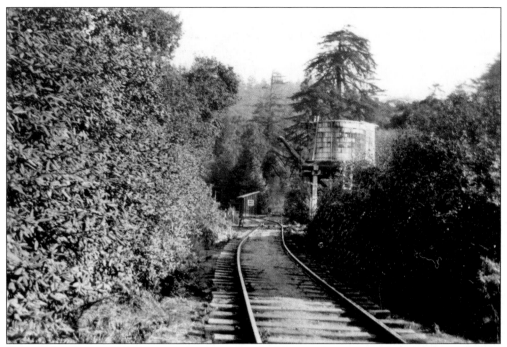

One of the Ocean Shore's water towers seems hidden in the trees in this woodsy area near Santa Cruz.

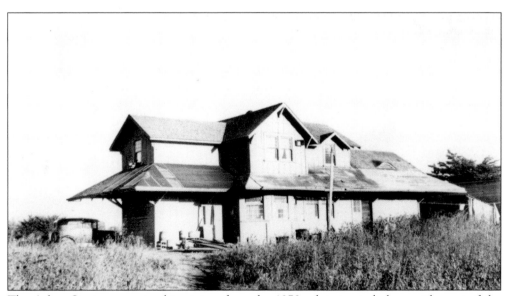

The Arleta Station, seen in this picture from the 1970s, deteriorated along with most of the other Ocean Shore stations.

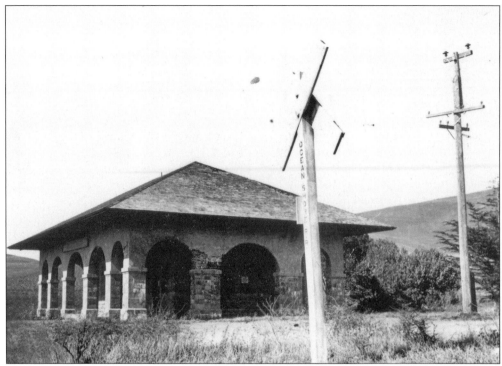

The Salada Beach Station, which began life with the hopes of becoming an integral transportation destination that would help an entire region blossom, wound up being completely destroyed, with only pictures left to show what it once looked like.

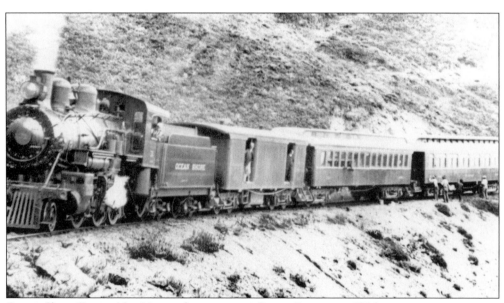

Ocean Shore Engine No. 31 rounds a corner at Green Canyon in 1916.

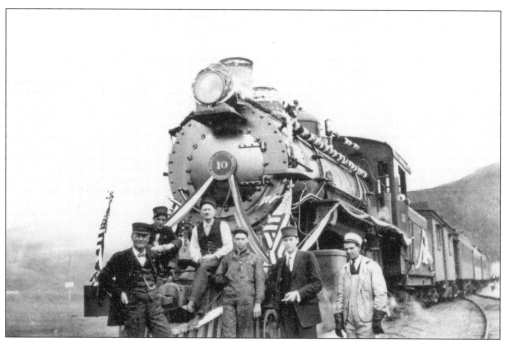

Ocean Shore Engine No. 10 is shown here near Tunitas. Note the Fourth of July decorations.

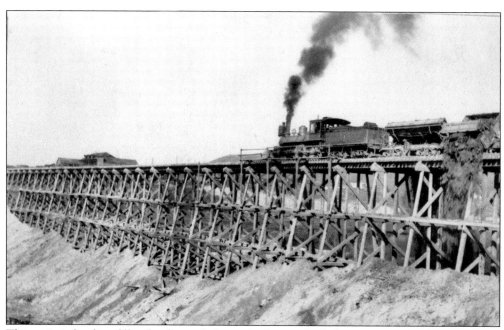

This train is hauling fill to be dumped alongside the trestle, bolstering its strength.

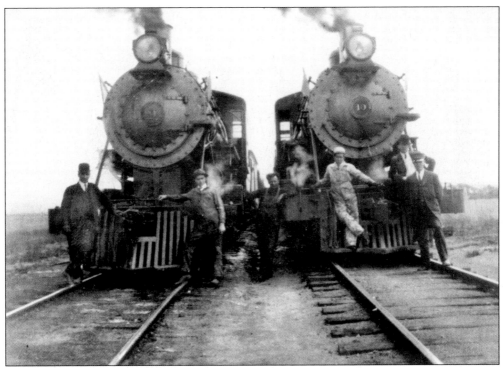

Ocean Shore trains No. 9 and No. 10 are shown side by side in Arleta around 1913.

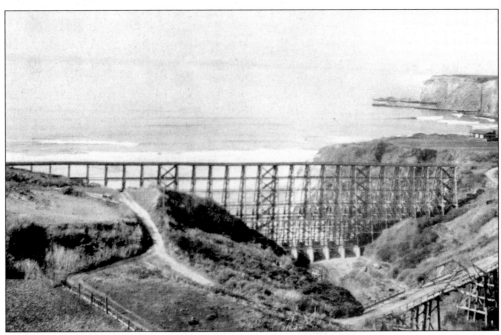

Perhaps one of the larger trestles along the route, this magnificent structure south of Pescadero allowed the Ocean Shore to cross the wide gap. Highway 1 today curves along the road path visible at the bottom of the picture. The trestle is long gone and the canyon view is now unobstructed.

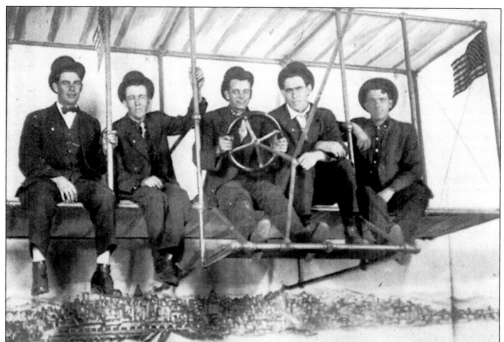

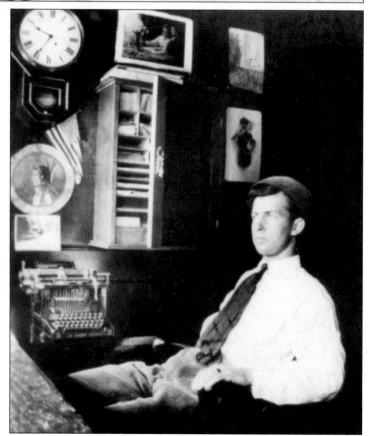

Ocean Shore engineers enjoy a celebratory party hanging from the makeshift wing of a plane above. Station agent Frank Simmons, in the picture at right, thinks about all the little details that must be managed for a railroad to be effective.

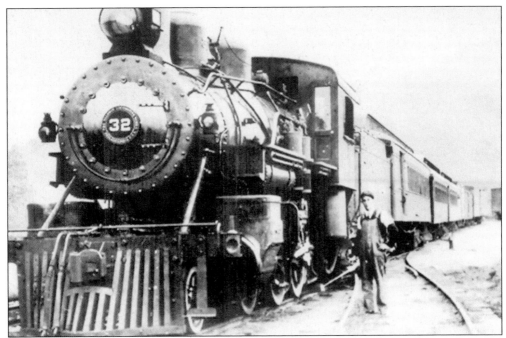

Ocean Shore locomotive No. 32 with its engineer pose for a photo somewhere near Tunitas in 1915.

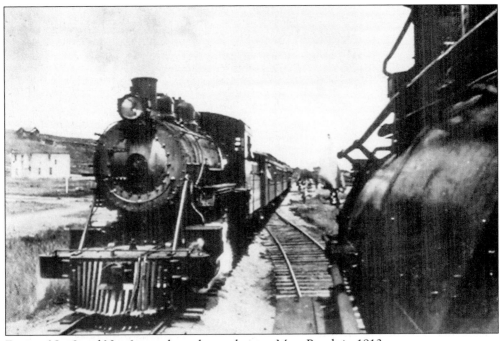

Engines No. 9 and No. 6 pass along the tracks near Moss Beach in 1913.

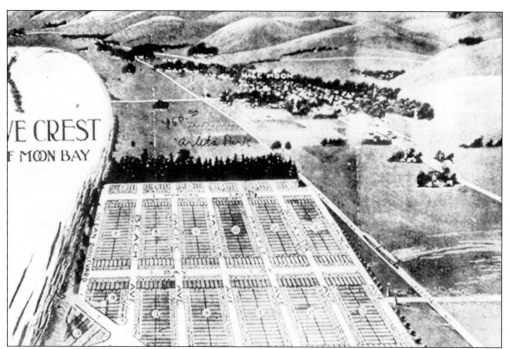

Marketing brochures promoted land speculation throughout the Ocean Shore line.

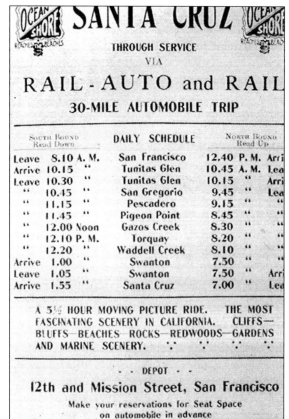

Timetables tried to make the automobile connection along the Ocean Shore into part of a "moving picture ride. The most fascinating scenery in California."

These Ocean Shore workers enjoy a brief respite from their efforts at the Swanton end of the southern portion of the railroad. Because of the 28-mile gap, the Ocean Shore had to deal with four "ends," essentially establishing in the public's mind that a "jitney" auto excursion between Tunitas and Swanton was a viable alternative to a complete railroad line from San Francisco to Santa Cruz. The company always wanted to complete the "gap" but never managed to raise the capital to do so.

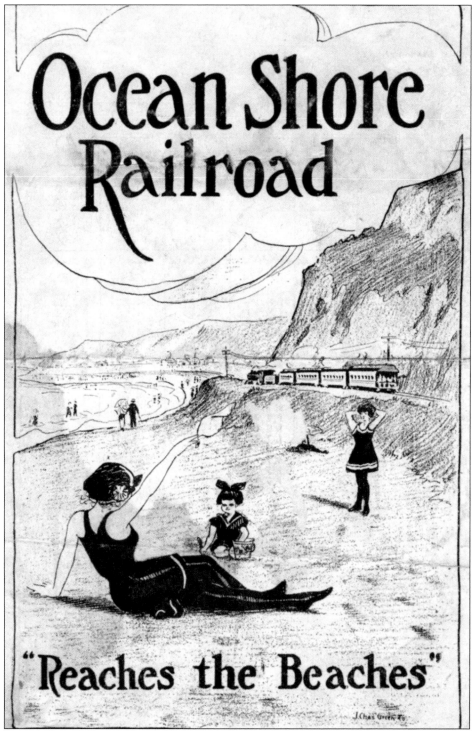

The most famous and most effective marketing campaign for the Ocean Shore involved the slogan "Reaches the Beaches," which hoped to lure residents as well as tourists to the coastside.

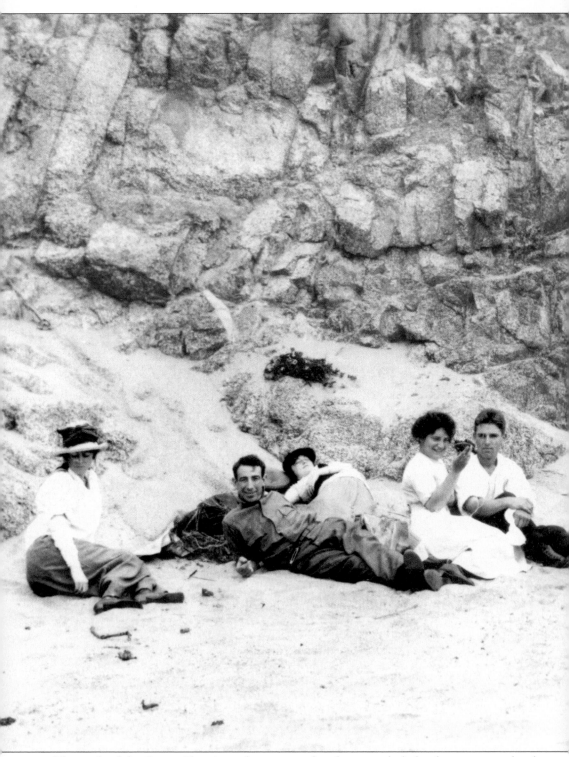

The truth of the Ocean Shore's marketing was played out regularly by the many people who

came to the beaches for picnics and entertainment.

Here, some workers horse around at the Twelfth and Mission Streets Station for the Ocean Shore Railroad in San Francisco.

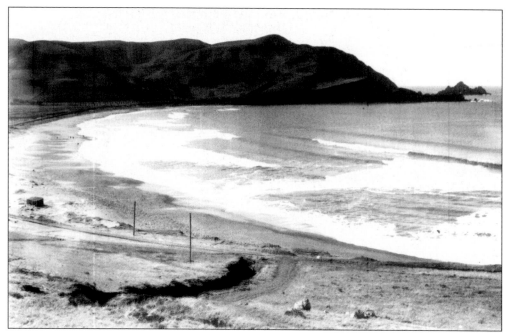

The tracks of the Ocean Shore Railroad can be seen looping around the beach, now called Pacifica State Beach, on their way to Pedro Point.

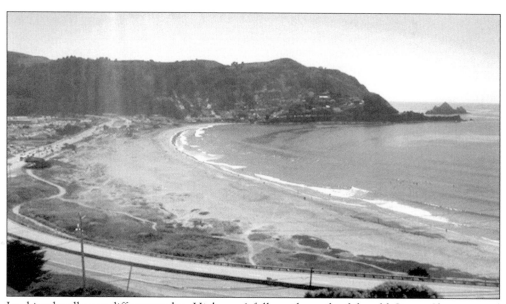

Looking hardly any different today, Highway 1 follows the path of the old Ocean Shore around Pacifica State Beach.

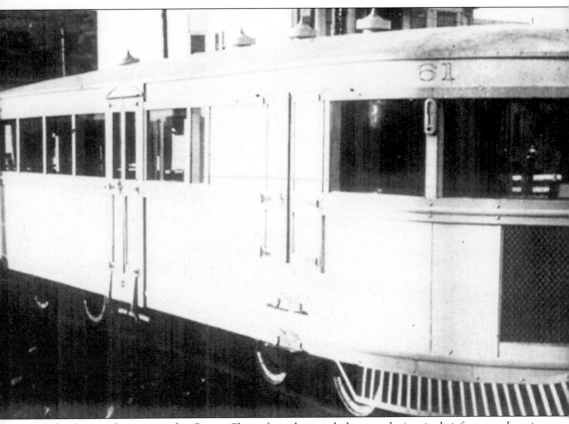

The financial strain on the Ocean Shore forced several changes during its brief career that, in hindsight, seem visionary. Originally intended to be an all-electric line, it morphed into a standard steam engine railroad before eventually shifting to a gasoline-powered engine system. Several prototype gas engines, intended to compete with the automobile, were used, but the salvation of the Ocean Shore was not to be realized. This gas-powered engine was said to cost a fraction of the price of running a standard railroad engine.

The improved train service which has been inaugurated this year is giving an impetus to all the beach towns from Salada to Half Moon Bay. There are now four trains each way daily and on Sunday, six trains make round trips. This service is stimulating a large excursion travel, from 2,000 to 3,000 people usually visiting the beaches every Sunday, while the regular weekday trains are well-filled with commuters and sightseers. Traffic manager I.N. Randall made the statement this week that the present service will be continued throughout the season. The trip down the Ocean Shore to Half Moon Bay is declared by tourists to present the most magnificent combination of mountain and marine views that can be seen from a car window anywhere in the world.

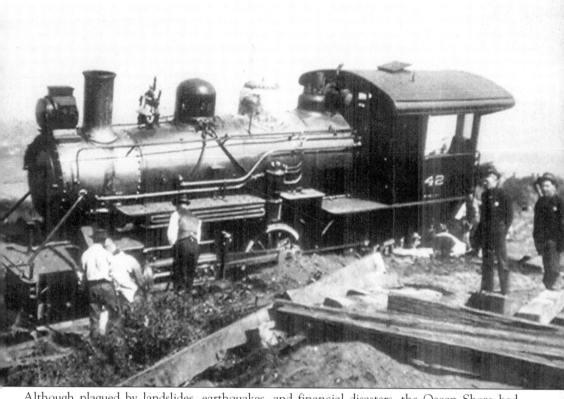

Although plagued by landslides, earthquakes, and financial disasters, the Ocean Shore had relatively few train accidents of any consequence. This derailment was symptomatic of the more typical rail problems, which were often due to bumps and rear-end collisions.

The fact that such a trip is within a short distance from a great city makes it still more impressive. At no distant time, when the Ocean Shore attractions are sufficiently advertised, it is believed that this will become a side trip that every tourist coming to the Pacific Coast will take.

The Ocean Shore Railroad is emerging from its coma state of bygone years and is showing progress. During the month of June, they carried 20,000 passengers, an increase of 100 percent over the number carried for the same month of last year.

—San Francisco Call, July 6, 1912.

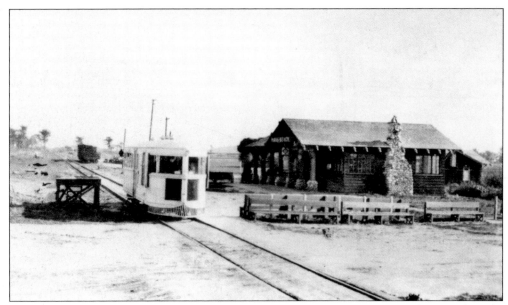

In this photo, the Moss Beach Station, looking very rustic with its stone fireplace on the side, is visited by the new-fangled gas-powered engine.

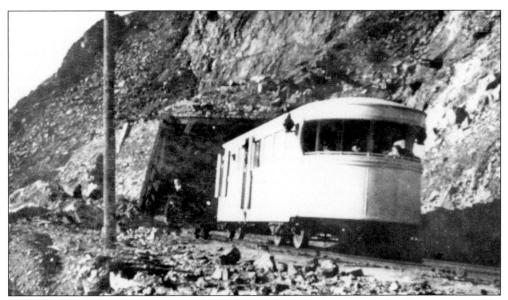

A modern-looking engine emerges from the southern end of the Pedro Point tunnel like something out of science fiction film rather than a 1918 photograph.

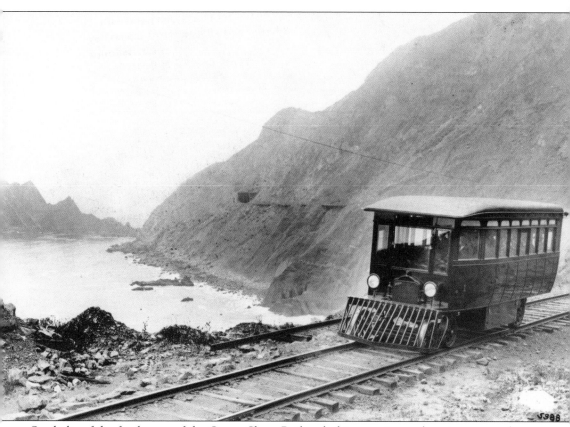

Symbolic of the final gasps of the Ocean Shore Railroad, this experimental engine was used as a promotional effort in 1920 and never really operated as part of the system. Not long afterwards the tracks were torn up and the equipment scattered to buyers following the sad dissolution of the railroad that hugged the coast.

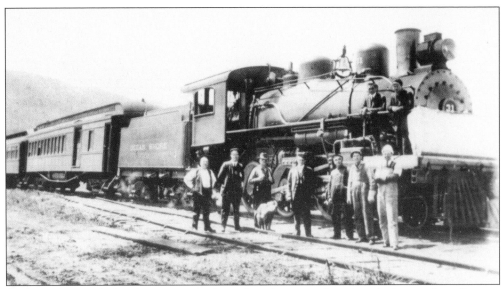

A crew poses in front of an engine equipped with a special testing device used to discover problems with the track and determine why engines were having trouble along specific areas.

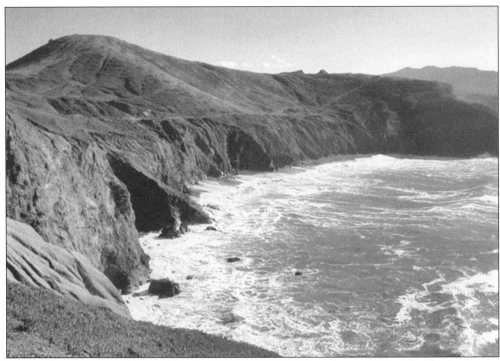

Mori Point, now part of the Golden Gate National Recreation Area, was avoided by the Ocean Shore, which passed on the eastern edge of it. Nonetheless, it was close enough to be considered part of the natural vistas enjoyed by rail passengers.

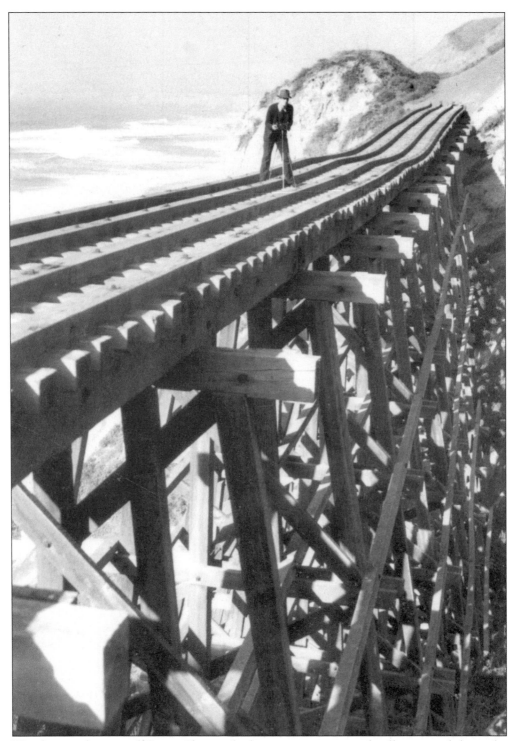

Wooden trestles carried Ocean Shore vehicles across canyons and gullies up and down the coast, creating unique manmade views. Somewhere there exists the photo this fellow took from atop this precarious trestle perch.

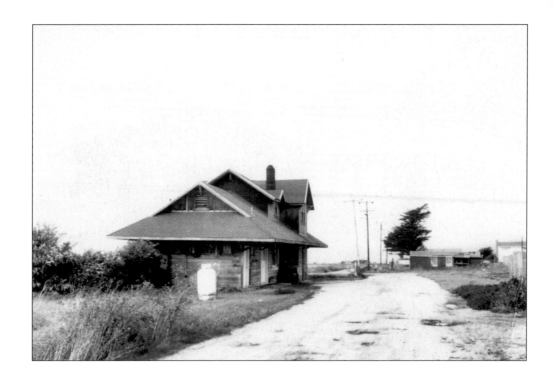

Ocean Shore stations, such as the Arleta Station shown here, survived long past the demise of the railroad itself. Like several others, Arleta Station evolved into a residence and then seemed to fade into memory.

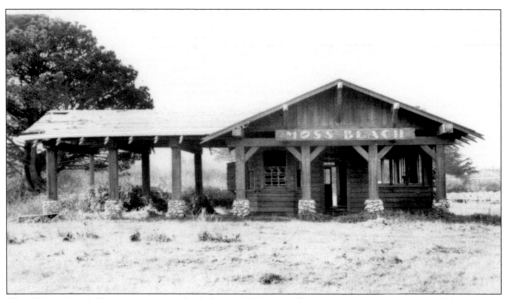

The Moss Beach Station as it looked about 1946 provides an evocative memory of the Ocean Shore Railroad days, which had ended 26 years earlier.

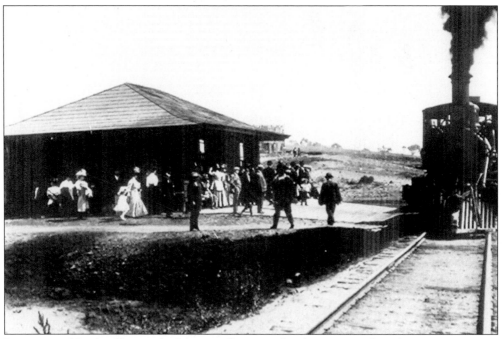

Locomotive No. 4 pulls into the Montara Station as locals prepare to board.

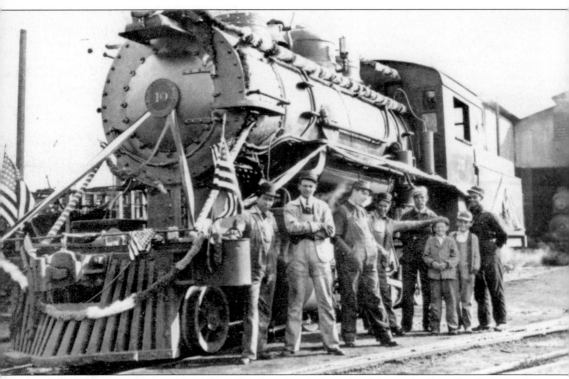

Ocean Shore locomotive No. 10 was decorated with flags to celebrate the Fourth of July for this picture in the San Francisco shops in 1913.

The first train on the Ocean Shore Railroad arrived at Edgemar at 11:52 a.m. Tuesday, Oct. 1, 1907, after a run of 17 and a half minutes from Ocean View. One hundred and twenty-five passengers and officials of the railroad were aboard. The passengers were surprised and delighted with the wonderful beauty of the road along the great bluffs at Mussel Rock where the breakers roil and their turbulent line of white hundreds of feet below. The first stop was made at Edgemar. The nearest seaside suburb.

—Ocean Shore marketing advertisement

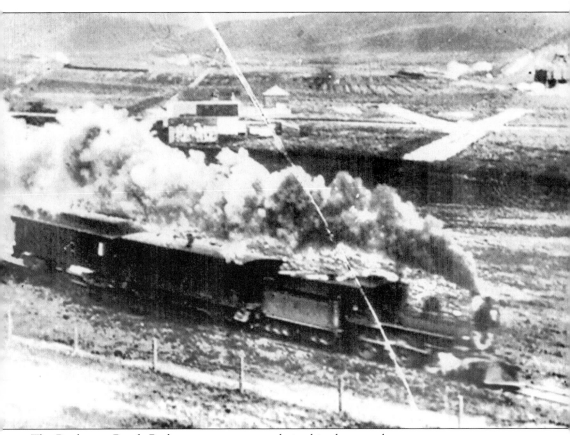

The Rockaway Beach *Rocket* seems pretty speedy in this photograph.

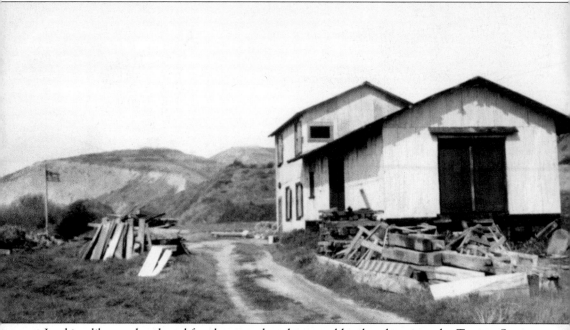

Looking like an abandoned farmhouse rather than an old railroad station, the Tunitas Station was only a faint reminder of the Ocean Shore in 1946.

Mary Edith Griswold, surely one of the finest real estate publicists, rode on the first run of the Ocean Shore and wrote that it opened

a new era in the development of ocean-beach properties in the peninsula. For years, ever since time began, three beautiful possibilities for homesites have lain idle, waiting for the coming of iron horse and the promoters—those pioneers of our times who go out into new untried financial fields, cultivate them and spread happiness to thousands by increasing the wealth of the world and making towns and cities grow up in the wilderness. It seems almost incredible that so rich and so beautiful a region as the coast south of Mussel Rock should have been left to the dairymen and the cabbage gardener all the years that the city dwellers have been looking for suburban homes. But the promoters of Edgemar purpose to preserve as much of this natural beauty, harmony and peace as possible.

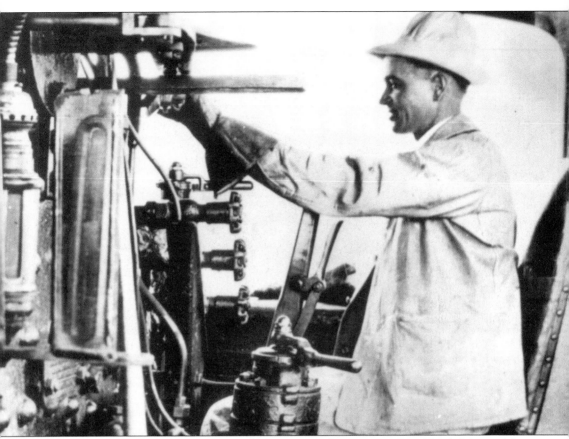

In this photo, Engineer Dave Parsley cranks up Ocean Shore Locomotive No. 2. Many of the people who worked on the Ocean Shore were longtime railroad crews. Ultimately, union solidarity and a strike against the Ocean Shore helped put it out of business in 1920. The little railroad was not able to compete with larger operations, such as the Southern Pacific, and could not pay its people comparable wages.

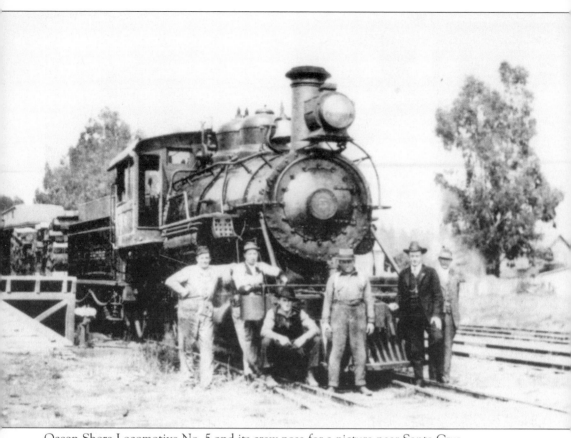

Ocean Shore Locomotive No. 5 and its crew pose for a picture near Santa Cruz.

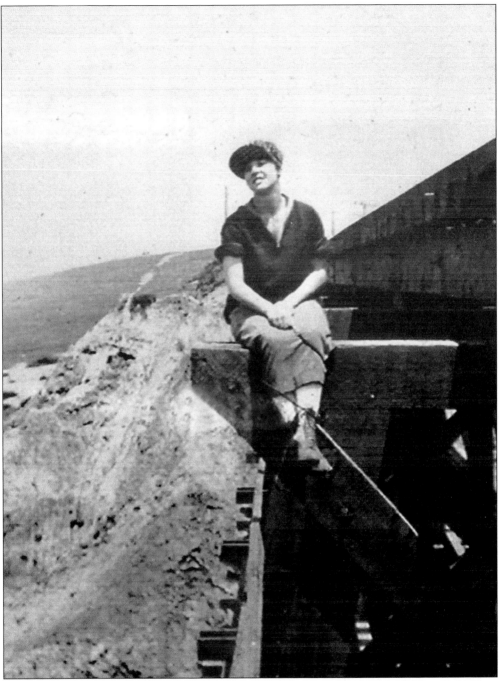

Ted Wurm's mother is shown here perched on the Montara trestle in 1916. The late Ted Wurm had a lifelong love affair with the Ocean Shore Railroad.

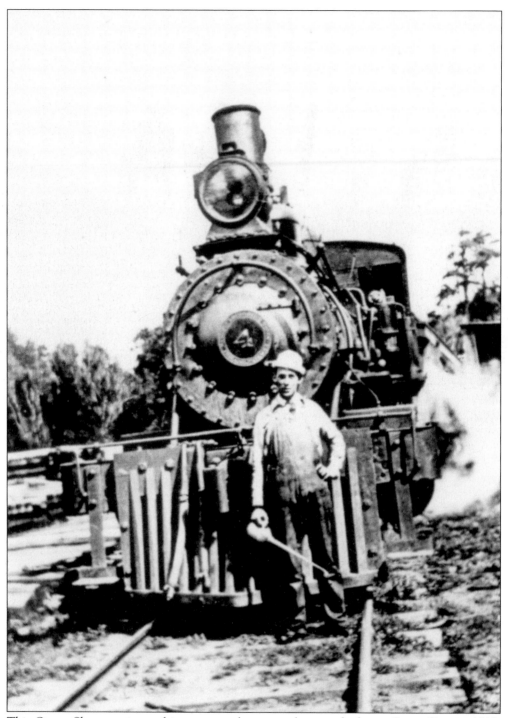

This Ocean Shore engine and its crewmember were photographed near Santa Cruz in 1917. Note the oilcan in the man's hand.

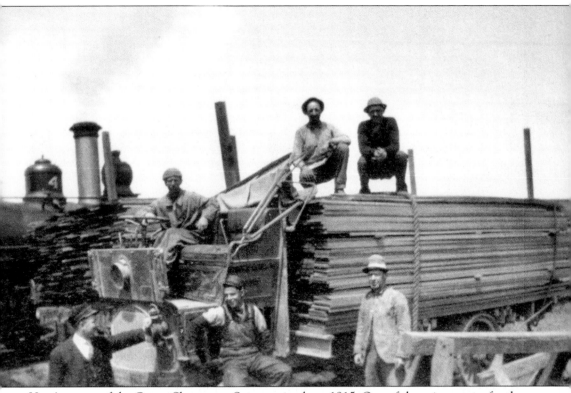

Here's a crew of the Ocean Shore near Swanton in about 1915. One of the primary uses for the Ocean Shore at the southern end was to haul lumber and cement from companies in that area. Unfortunately, both industries were able to develop independent deals with other railroads, cutting off the financial contracts that could have helped the Ocean Shore become viable.

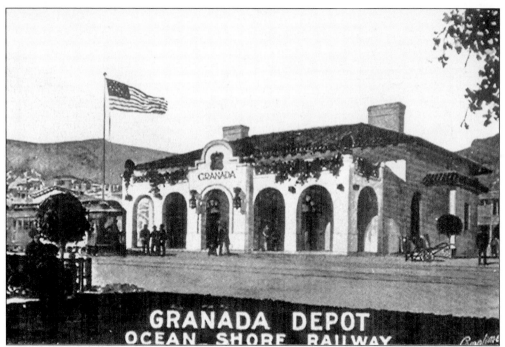

GRANADA DEPOT
OCEAN SHORE RAILWAY

The town of Granada, now called El Granada, was expected to become a fabulous resort. With streets laid out by Daniel H. Burnham in a concentric circle grid, it had three Ocean Shore stations. Like most other plans related to the Ocean Shore, El Granada's hoped-for prominence never materialized, although the confusing streets still remain.

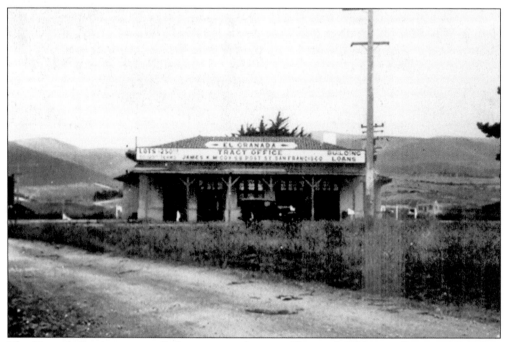

The Granada Station eventually became a real estate office, as did Edgemar Station in Pacifica, but today little evidence remains of a railroad passing through El Granada.

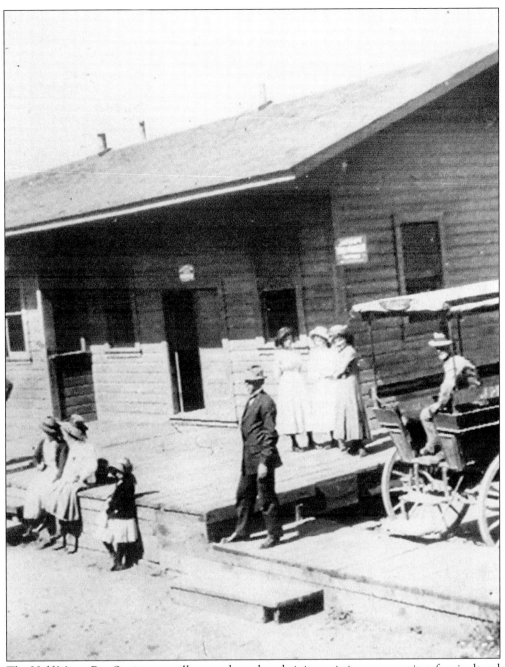

The Half Moon Bay Station actually served a rather thriving existing community of agricultural and commercial strength. The little city, which continues to be the dominant tourist attraction along the San Mateo County coast, has blossomed into a wealthy enclave that includes a brand new Ritz-Carlton resort hotel.

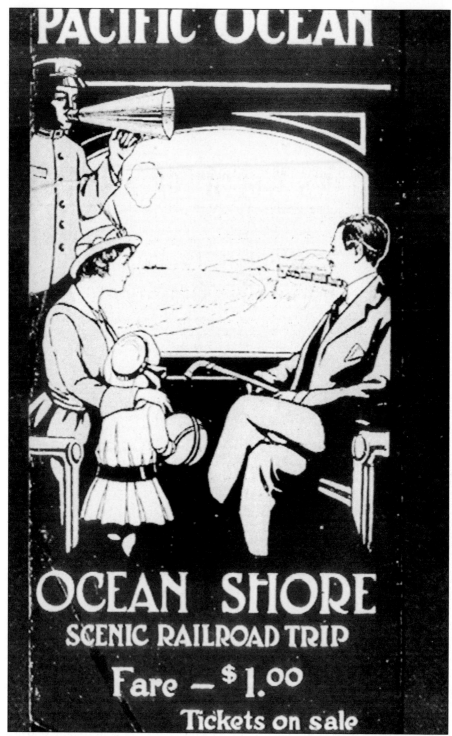

Marketing advertisements encouraged people to see the sights along the coast. The success of the Ocean Shore depended upon many people taking them up on the offer. Not enough did.

The Ocean Shore Trip

Excursion De Luxe

A Dollar's Worth For A Dollar

The Most Delightful Four-hour Jaunt on Five Continents

EXCURSIONS LEAVE

10 a. m. Every Day, Back at 4:15 p. m.

8:10 and 10 a. m. on Sunday, Back at 5 p. m.

FROM

DEPOT:—12th and Mission Streets

TICKETS ON SALE AT DEPOT

OR

UNION SIGHT-SEEING STATION	-	687 Market Street
COOK'S TOURS - - - - -		689 Market Street

" PHONE MARKET 46 "

It was a relatively inexpensive price to pay for a ride along the ocean. Those who did so, especially on a sunny day, remembered it for a lifetime.

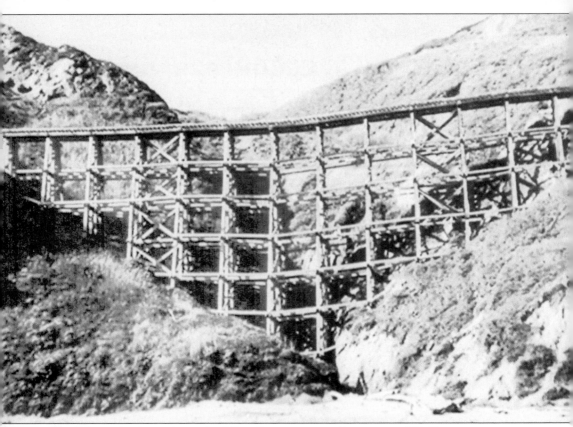

The Palmer Creek trestle south of San Gregorio was still intact as of 1935.

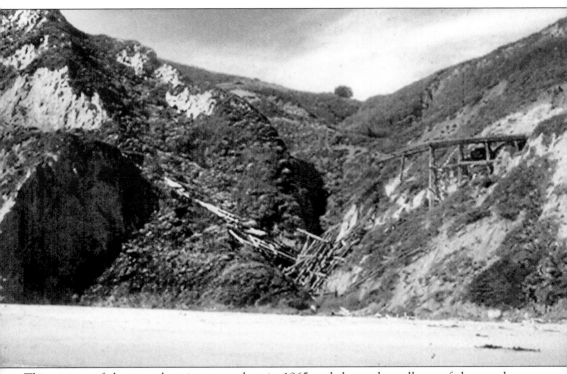

This picture of the same location was taken in 1965 and shows the collapse of the wooden trestle structure.

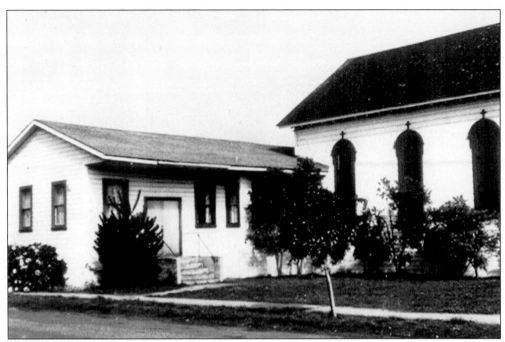

The former Ocean Shore station in Half Moon Bay was moved from its location and used as an addition to a local church.

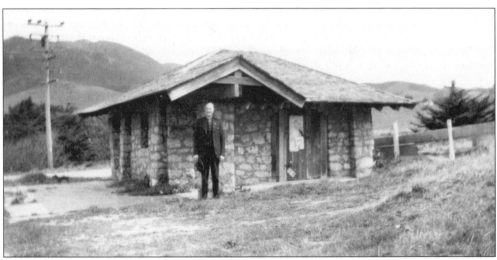

This photo from the 1940s shows the old Farallone Station long after the last Ocean Shore train came by, with an unidentified man posing in front.

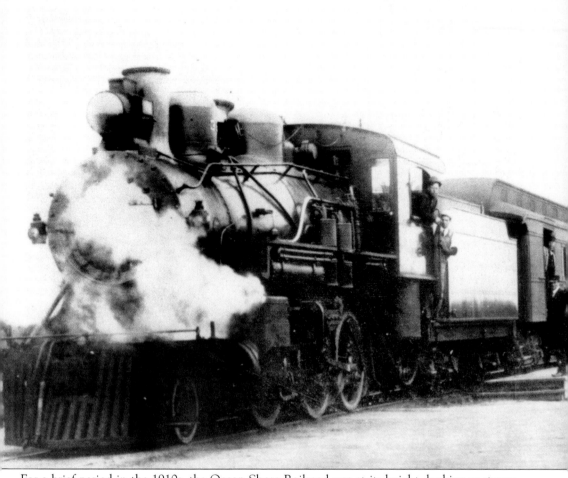

For a brief period in the 1910s, the Ocean Shore Railroad was at its height, looking as strong and vibrant as any railroad anywhere. But the little Ocean Shore didn't have the strength of other railroads, making a profit of only $18,000 in 1912 and then sliding down the bankruptcy slope until its collapse in 1920. But for a brief flicker of time it worked, carrying people to and from the coastside between San Francisco and Santa Cruz.

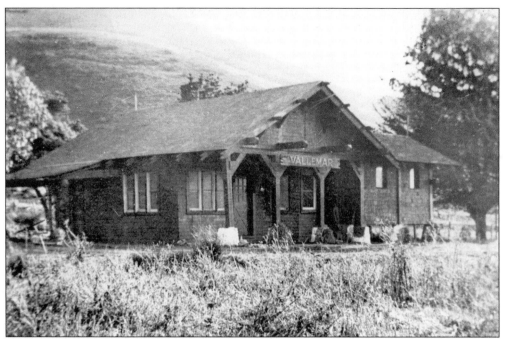

The Vallemar Station, looking rustic and abandoned above, is perhaps the only station that maintained a public face throughout the decades, emerging as the site of various restaurants and currently the location of Ash's Vallemar Station.

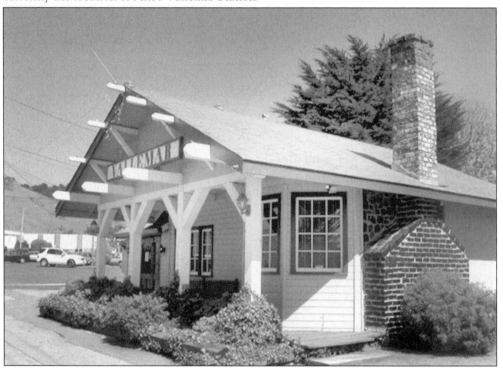

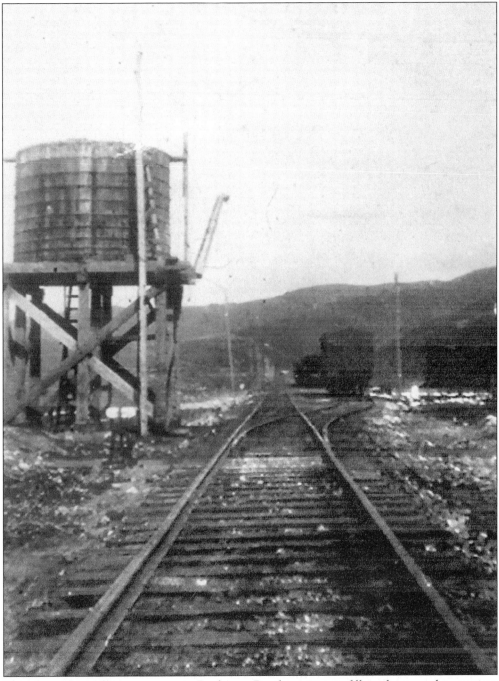

This photo shows the water tower in Rockaway Beach, waiting to fill up the steam locomotives that ran on the Ocean Shore Railroad.

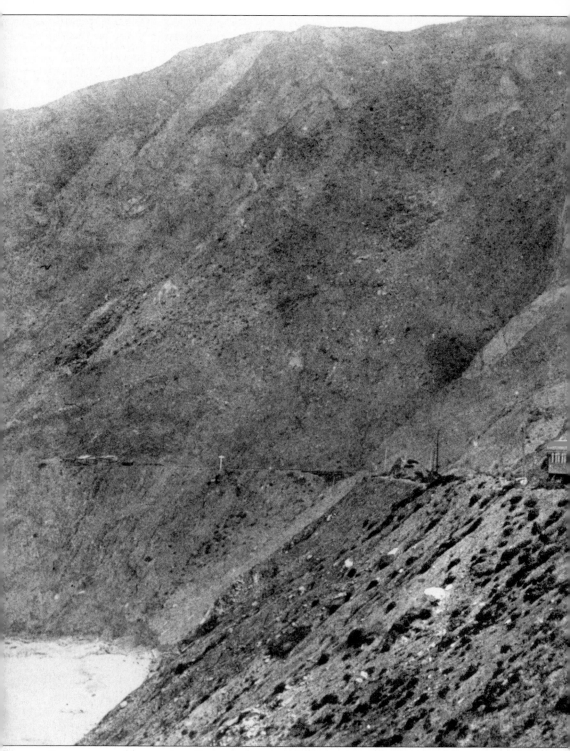

Passengers could marvel at glorious seascapes while peering out one side of the Ocean Shore

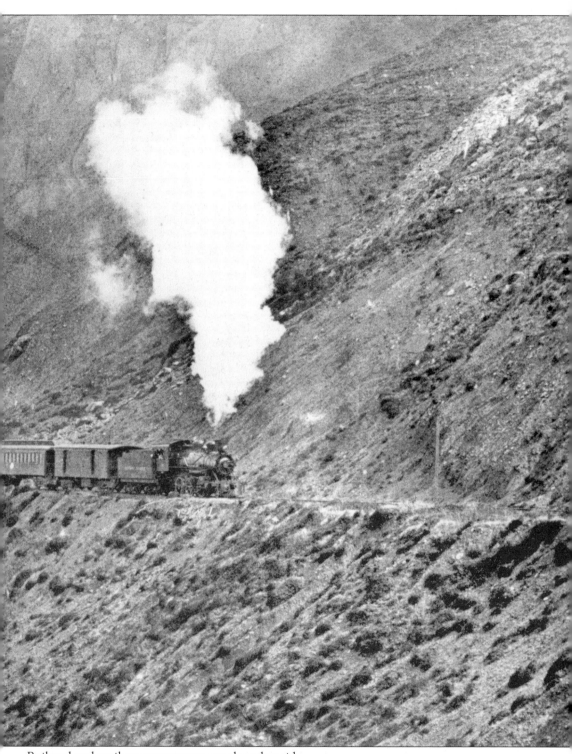

Railroad and perilous moonscapes out the other side.

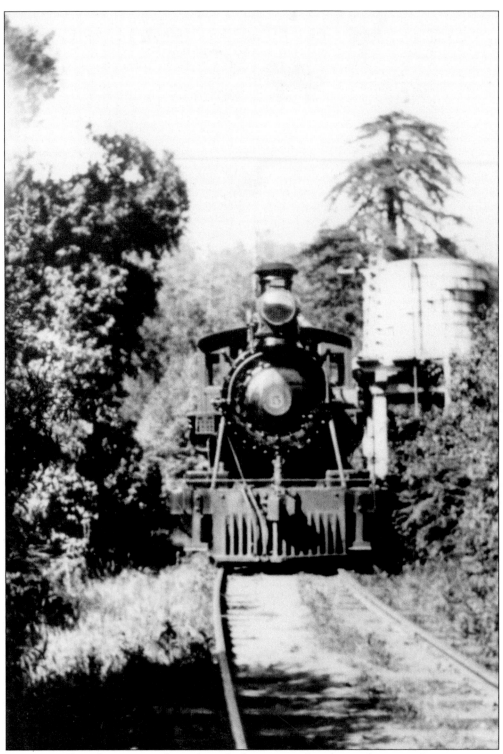

An Ocean Shore locomotive chugs through the trees in this photo taken near Swanton.

OCEAN SHORE RAILROAD

(NORTHERN DIVISION)

Depot—Twelfth and Mission Streets

Telephone Market 46

"Reaches the Beaches" **OFFICIAL TIME TABLE** "Reaches the Beaches"

Effective May 1, 1915

11	9	7	5	3	1	Miles	BETWEEN SAN FRANCISCO AND HALF MOON, ARLETA TUNITAS AND INTERMEDIATES	2	4	6	8	10
Anglers' Special — Sundays only	Afternoon Excursion — Sundays only	Half Moon Express — Daily (See Note Below)	Half Moon Passenger — Daily	Scenic Limited — Daily (See Note Below)	Tunitas Passenger — Daily		GOING (Read Down) / RETURNING (Read Up)	The Commuter — Daily	Half Moon Express — Daily	Tunitas Express — Daily	S.F. Passenger — Daily (See Note Below)	S.F. Passeng — Sunday only
7.00 AM	1.30 PM	*5.45 PM	3.00 PM	*10.00 AM	8.10 AM	0	SAN FRANCISCO	7.20 AM	8.40 AM	1.15 PM	*5.15 PM	7.45
f	f	f	f	f	f	0.8	Sixteenth Street	f	f	f	f	f
f	f	f	f	f	f	1.9	Twenty-fourth Street	f	f	f	f	f
s 7.10	s 1.45	s 6.00	s 3.15	s10.15	s 8.25	2.5	Shops	s 7.10	s 8.25	s 1.03	s 5.00	s 7.30
f 7.23	f 1.53	s 6.08	s 3.23	f10.23	f 8.33	5.4	Onondago	f 7.03	f 8.16	f12.54	f 4.51	f 7.22
f 7.27	f 1.57	f 6.12	f 3.26	f10.27	f 8.37	7.1	Palmetto	f 6.59	f 8.12	f12.50	f 4.47	f 7.18
f 7.29	f 1.59	f 6.14	f 3.28	f10.29	f 8.39	7.6	Daly City	f 6.57	f 8.11	f12.49	f 4.46	f 7.16
f 7.36	f 2.05	f 6.20	f 3.33	f10.35	f 8.45	9.9	Thornton	f 6.52	f 8.04	f12.43	f 4.39	f 7.09
f 7.43	f 2.10	f 6.25	f 3.38	f10.41	f 8.50	11.9	Mussel Rock	f 6.47	f 7.58	f12.37	f 4.33	f 7.03
f 7.47	f 2.13	f 6.28	f 3.41	f10.44	f 8.53	13.1	Edgemar	f 6.44	f 7.55	f12.33	f 4.30	f 7.00
s 7.52	s 2.17	s 6.32	s 3.44	s10.48	s 8.57	14.3	SALADA	s 6.41	s 7.52	s12.30	s 4.27	s 6.57
f 7.54	f 2.18	f 6.33	f 3.45	f10.49	f 8.58	14.8	Brighton	f 6.39	f 7.50	f12.28	f 4.25	f 6.55
f 7.57	f 2.21	f 6.36	f 3.48	f10.53	f 9.01	16.0	Vallemar	f 6.36	f 7.47	f12.25	f 4.22	f 6.52
s 7.59	s 2.23	s 6.38	s 3.50	s10.55	s 9.03	16.6	Rockaway	s 6.34	s 7.45	s12.24	s 4.20	s 6.50
s 8.04	s 2.28	s 6.45	s 3.54	s11.01	s 9.08	18.1	TOBIN	s 6.29	s 7.40	s12.20	s 4.15	s 6.45
f 8.07	f 2.31	f 6.50	f 3.57	f11.04	f 9.11	18.9	Ransome	f 6.26	f 7.37	f12.17	f 4.12	f 6.42
f 8.15	f 2.39	f 6.58	f 4.04	f11.12	f 9.19	21.1	Green Canon	f 6.18	f 7.29	f12.10	f 4.04	f 6.34
f 8.19	f 2.43	f 7.02	f 4.10	f11.16	f 9.23	22.8	Montara	f 6.14	f 7.25	f12.05	f 4.00	f 6.26
s 8.21	s 2.45	s 7.04	s 4.14	s11.18	s 9.25	23.0	FARALLONE	s 6.13	s 7.24	s12.04	s 3.59	s 6.20
s 8.25	s 2.48	s 7.07	s 4.17	s11.22	s 9.28	24.1	MOSS BEACH	s 6.09	s 7.20	s12.00M	s 3.55	s 6.16
f 8.29	f 2.49	f 7.08	f 4.18	f11.24	f 9.29	24.4	Marine	f 6.08	f 7.18	f11.58	f 3.53	f 6.11
f 8.29	f 2.53	f 7.12	f 4.22	f11.30	f 9.33	26.0	Princeton	f 6.05	f 7.15	f11.54	f 3.50	f 6.08
f 8.31	f 2.55	f 7.14	f 4.24	f11.32	s 9.35	26.5	North Granada	f 6.03	f 7.13	f11.52	f 3.48	f 6.05
s 8.32	s 2.56	f 7.16	f 4.27	s11.32	s 9.36	27.1	Granada	s 6.02	s 7.12	s11.51	s 3.47	s 6.03
f 8.33	f 2.58	f 7.16	f 4.28	f11.34	f 9.38	27.6	SOUTH GRANADA	f 6.01	f 7.11	f11.52	f 3.45	f 6.01
f 8.36	f 2.59	f 7.17	f 4.28	f11.38	f 9.39	28.1	Miramar	f 6.00	f 7.10	f11.49	f 3.45	f 5.59
s 8.40	s 3.05	s 7.23	s 4.35	f11.40	s 9.45	30.2	HALF MOON	s 5.55	s 7.05	f11.35	s 3.40	s 5.53
s 8.52	f 3.15	f 7.25 PM	f 4.40 PM	f11.52 AM	f 9.57	30.8	Arleta	5.50 AM	7.00 AM		f 3.35 PM	f 5.48
f 8.56	f 3.18	No. 7 Through to Tunitas Saturdays Only		No. 3 Through to Tunitas Sundays Only	f10.01	32.6	Fairhaven				f11.30	f 5.45
f 9.00	f 3.21				f10.05	34.3	Purisima				f11.25	f 5.41
f 9.01	f 3.22				f10.07	34.8	Sealrox				f11.22	f 5.38
f 9.05	f 3.25				f10.10	36.1	Lobitos				f11.18	f 5.35
9.10 AM	3.30 PM				*10.15 AM	38.0	TUNITAS				*11.10 AM	5.30

No. 8 From Tunitas Sundays Only at 3:15 P. M.

s—Regular Stop. f—Flag stop to receive or discharge passengers.

NOTE: *Trains Nos. 1 and 6 connect with Auto Stage daily to and from San Gregorio, La Honda, Bellevale, Pescadero, Pebble Beach, Swanton and Santa Cru[z]
*Train No. 7 through to Arleta daily; through to Tunitas Saturdays only.
*Trains Nos. 3 and 8 to and from Arleta daily, Tunitas Sunday only.

For information regarding

BATHING—BOATING—FISHING—HUNTING—TRAMPING OR PICNICS

Write I. N. RANDALL, General Agent, San Francisco

The Ocean Shore offered a comprehensive schedule for travelers, but it was whittled away through the years as cost-cutting measures pared back trains.

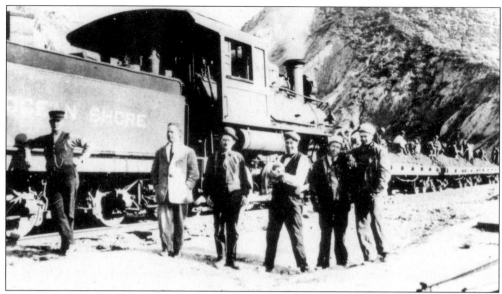

This group of men poses near an Ocean Shore engine working on the Mussel Rock area of the northern line.

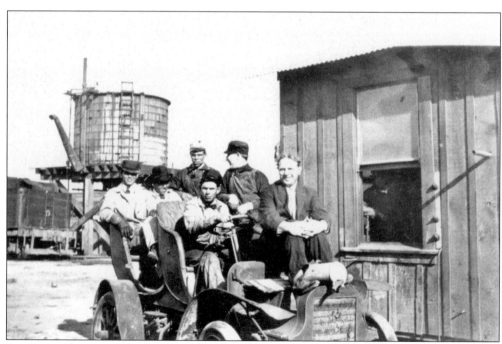

An Ocean Shore roundhouse crew jokes aboard a jitney in 1913. Crews, like passengers, had to use automobiles to cross the 26-mile gap between Swanton and Tunitas.

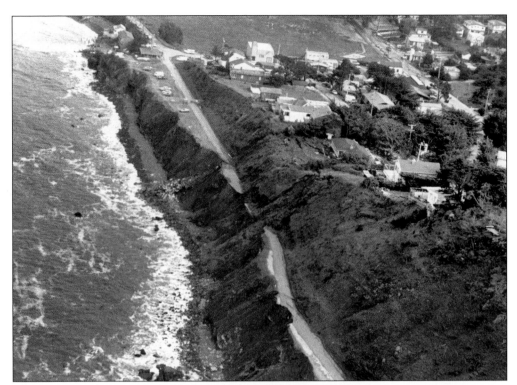

Above, an aerial view of Pedro Point shows the collapse of the roadway leading to the Shelter Cove resort. Like the Ocean Shore Railroad right-of-way, which originally carved the ledge to reach the point, the roadway was constantly being repaired. Today, it is a footpath leading to privately owned property, which at one time was a thriving oceanfront resort.

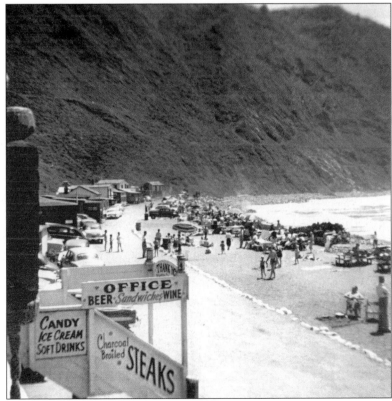

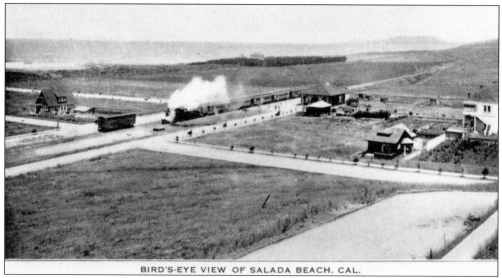

BIRD'S-EYE VIEW OF SALADA BEACH, CAL.

There was little for a bird to see at Salada Beach when the Ocean Shore chugged through the coastal area *c.* 1908.

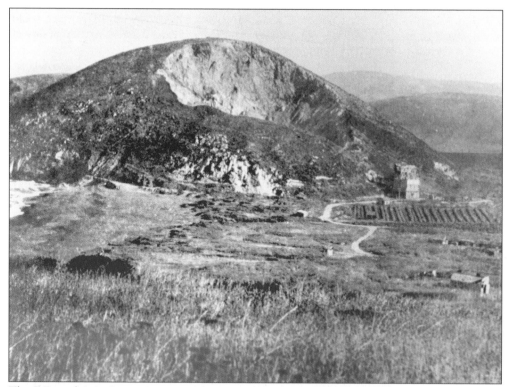

The E.B. and A.L. Stone Company quarry in Rockaway eventually whittled away most of the limestone mountain. The Ocean Shore benefited from the presence of the quarry while it could run trains to and from San Francisco, with a spur line into the quarry. Today the property is no longer an active quarry and is privately owned.

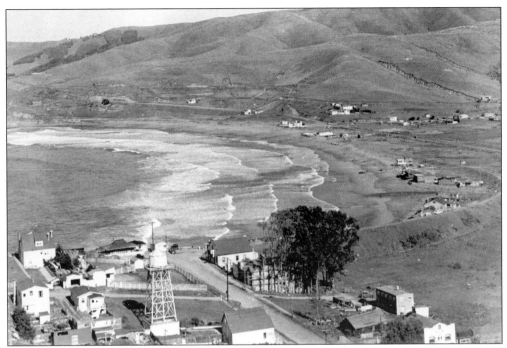

The Ocean Shore Railroad had a lot to do with creating a residential climate for what would become Pacifica. This view of the old rail berm coming to Pedro Point shows the beauty of Linda Mar Beach, now Pacifica State Beach.

The cliffs along the northern part of Pedro Point have always been dangerous, whether Ocean Shore trains cling to the side or cars. Today, there is just a walkway where once trains and automobiles traveled.

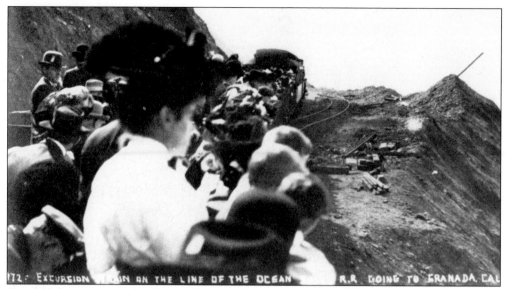

172 - EXCURSION TRAIN ON THE LINE OF THE OCEAN R.R GOING TO GRANADA CAL

Demand for a trip on the Ocean Shore was at one time so great that the railroad had to accommodate travelers on special flatcars equipped with seats. One can only imagine the precarious nature of the trip as the trains chugged along the cliff sides. It was undoubtedly a memorable ride; enough so that many postcards were printed promoting the excitement of the "excursion."

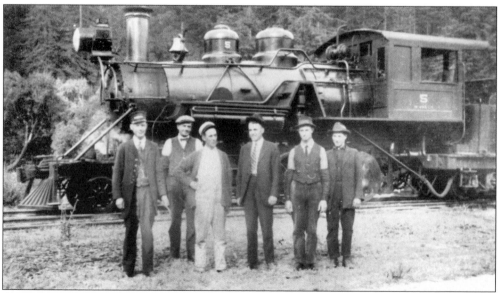

A group of engineers and crew pose next to Ocean Shore Locomotive No. 5 near the southern part of the railroad system.

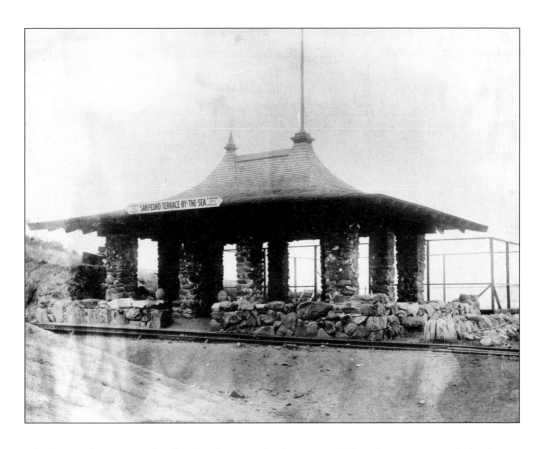

The San Pedro Terrace by the Sea Station, also known as Tobin Station or just Pedro Point, was the southernmost station before the Ocean Shore Railroad moved south along Devil's Slide. Today it is a private residence but is still easily identifiable as a former train station.

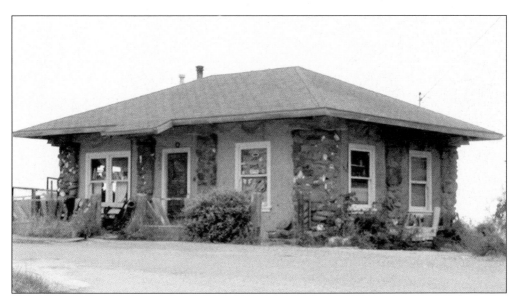

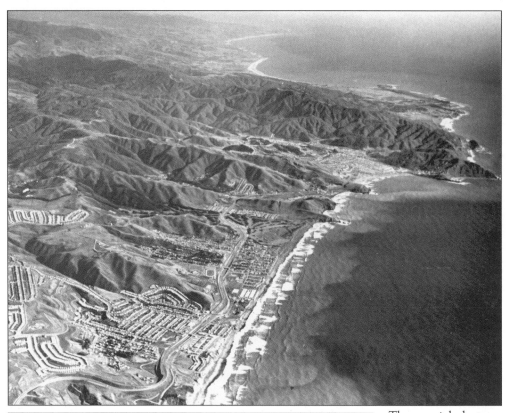

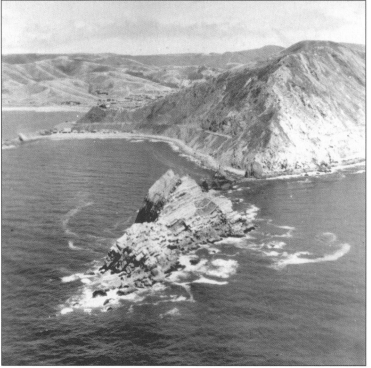

These aerial photos show the path of the Ocean Shore Railroad as it traveled south from Mussel Rock along the coast of what is now Pacifica. The sharp edge of Pedro Point was pierced by a 340-foot tunnel, allowing the tracks to continue south toward Half Moon Bay, clinging to what is appropriately named Devil's Slide.

The Sanchez Adobe in Pacifica was a tourist attraction in the days of the Ocean Shore Railroad and continues to be an historical delight to this day. The Spanish adobe was a hotel in the days of the Ocean Shore, but is part of the San Mateo County Historical Association's holdings today.

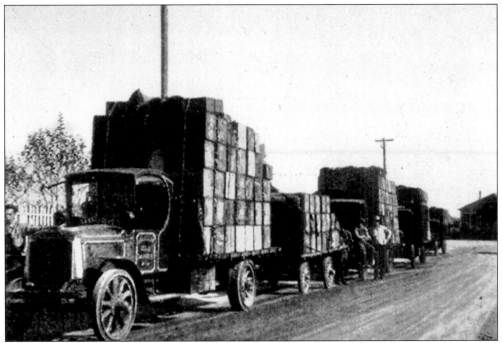

The promise of agricultural transportation contracts for the Ocean Shore Railroad—contracts that would take artichokes to market and enable the railroad to compete financially—lasted a few years, but eventually trucks came to dominate produce hauling.

With Highway 1 crossing in front of it exactly where the old Ocean Shore Railroad tracks once passed, the former Vallemar Station is perhaps the most visible reminder of the area's rail history. Other railroad cars, now used by commercial tenants, were placed in the vicinity by Pete Pereira, also echoing the Ocean Shore legacy.

Six

TRAINS LOSE OUT
TO AUTOMOBILES

The Ocean Shore Railroad struggled mightily after the devastating losses of the 1906 earthquake. Subsequent efforts to raise bond money failed as San Franciscans chose to rebuild in their beloved city rather than abandon it for the fantasy playgrounds being promoted along the San Mateo County coast.

The burgeoning popularity of the automobile is often said to have delivered the death blow to the Ocean Shore Railroad, as people chose the independence of the new automobile age over the delights—and drawbacks—of a railroad system, a problem that has plagued more mass transits efforts than just the Ocean Shore Railroad.

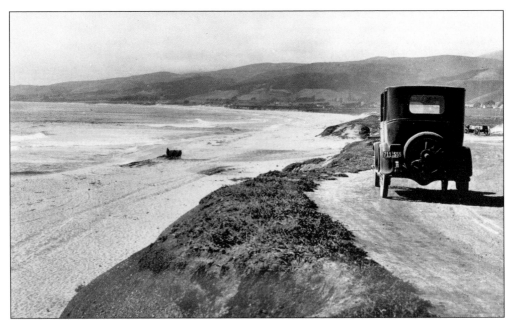

This photo of an automobile perched on the berm along the coast near Half Moon Bay is a perfect depiction of what ultimately killed the Ocean Shore Railroad by most accounts; the ease of individual transportation created by roadways and cars trumped the need for public transportation along the coast. The car continues to dominate the San Mateo County coast, while mass transportation efforts focus on the interior of the peninsula.

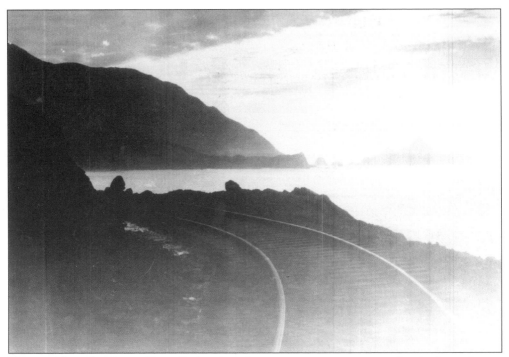

The vista from the Ocean Shore Railroad tracks was awe-inspiring to travelers in the early part of the 20th century.

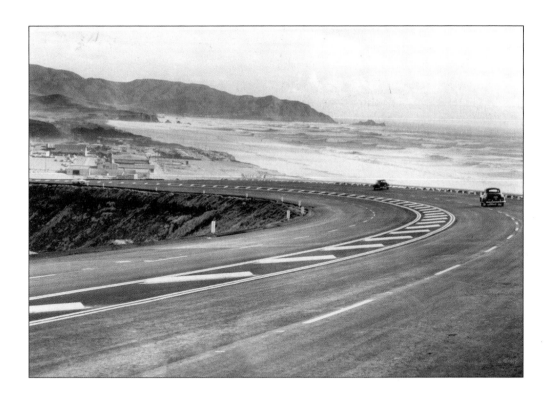

This early 1960s photo of Highway 1 coming into Pacifica shows the same scenic vista as that on the previous page and is indicative of why the Ocean Shore could not compete with automobiles. The recreational opportunities at Pedro Point are no different today than they were in 1915, and the Ocean Shore's railroad ledge is still visible cutting across the point. The old Tobin Station is near the left edge of the photograph below, at the end of the line of cars.

Disposing of Ocean Shore equipment even meant using an engine in an early form of "demolition derby," destroying old train engines for the enjoyment of the crowd. Such a spectacle would undoubtedly draw an audience even today.

The World's Greatest Sensation
MIGHTY!—DASH!—CRASH!—SMASH!
HEAD = ON
RAILROAD COLLISION
Between Two Monster Railroad Engines
Sacramento State Fair Grounds
Sunday, Sept. 6
AT 2 P. M.
PROMOTED and DIRECTED PERSONALLY BY JOHNSON & WOODS

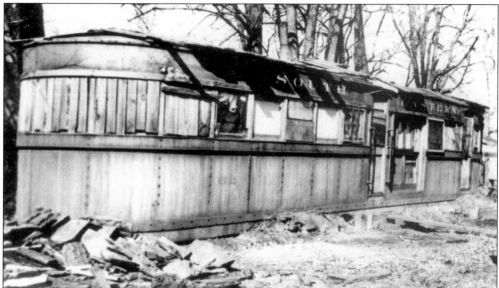

When the end came, Ocean Shore Railroad equipment was sold to anyone interested in buying it, and was thus scattered far and wide. The car above was sold to a buyer in Oregon and used as a diner. The engine at right was sold to the California Wine Association. Even today, people sometimes stumble across a bit of Ocean Shore memorabilia, often rusting away in a Central Valley field.

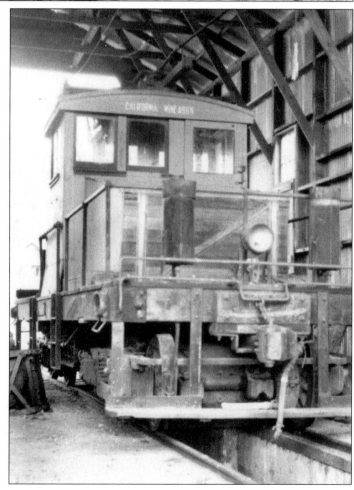

Railroads Cannot Be Run Without Patronage

Editor the Chronicle— Sir: 'Tis to laugh—the grief of the artichokers over the demise of the Ocean Shore. For years they shipped their stuff by truck—incidentally wrecking the highway—and stage lines are permitted to grow up and absorb revenue rightly belonging to the railroad. The Ocean Shore people have been rather good sports to have carried their enormous losses as long as they have in the face of the non-support of the villagers. There is no question but that their losses could have been materially decreased by the operation of lighter equipment in place of their heavy trains. One-man cars would have sufficed for most of the traffic. Now we have the picture complete: rusting rails, ruined roads, weeping wops and the grins of the gasoline barons. S. O. LONG.

This 1920 letter to the editor from the coyly named S.O. Long, has a biting edge to it that reveals some of the hard feelings about the end of the Ocean Shore Railroad.

Seven

No More Ocean Shore ... Railroad, That is

Although it ended in 1920, the Ocean Shore Railroad continued to exist as a legal entity for decades after its last train chugged along the coast. Easements and rights-of-way remained the property of the descendants of the original Ocean Shore founders.

One of the more unique instances of the Ocean Shore being "revived" involves the Pacifica School District. Because the train's tracks once ran right through the middle of what eventually became a playground at the Pacific Manor School, a legal and long-term friendly agreement that had existed since 1958 kept both parties content. The Ocean Shore didn't pay property tax and the school didn't worry about its playground.

But when the school district decided to renovate the facility, causing part of the new building to encroach on the Ocean Shore easement, a legal battle ensued. The school district attempted to take the property through eminent domain and the Ocean Shore sued for more money. Ultimately, in 2002, a jury trial decided to award the Ocean Shore heirs $275,000 for the strip of property running through the back of the school yard. It was more than the district had wanted to pay but less than the Ocean Shore had demanded.

This playground space at what was once Pacific Manor School was part of the original Ocean Shore Railroad easement. Until the school, now called Ocean Shore School, needed to expand, a legal arrangement with the Ocean Shore heirs and the school district maintained a simple, cordial relationship.

Ironically, the Pacific Manor School changed its name and is now known as Ocean Shore School, demonstrating a fondness for the history of the little railroad that once ran through the playground. In 2004, there was a small notice of a tax default for about $30 relegated to the Ocean Shore Railroad for a tiny piece of property. The fact that the Ocean Shore Railroad spent less than two decades in the transportation business and more than seven decades as a legal entity squabbling over property rights is yet another detail that adds to its fascinating story.

Eight
THE MODELERS REVIVE THE MEMORY

No one has done more to revive interest in the Ocean Shore Railroad in recent years than Armando and Danilo Vargas, twin brothers who make their living designing and building exquisite models of railroads and railroad environments.

Their enthusiasm for the Ocean Shore Railroad comes from more than 20 years of passing the coast and seeing the route of the Ocean Shore Railroad right-of-way. Because of this enthusiasm, both men were prompted to build an accurate railroad model to show the public how unique this historic railroad that hugged the Pacific Coast and Devil's Slide really was.

"But before doing what we enjoy most, creating miniature wonderlands to view, we wanted to model the Ocean Shore as accurately as possible, so historians could enjoy from a bird's eye view how incredible it must have been to ride the train along the cliffs of the coast," Danilo recalls. "Armando and I owe all of our inspiration and drive to complete our dream to Ted and Betty Wurm for the way they embraced us in friendship and trust, giving us Ted's lifelong dream of an Ocean Shore Railroad book featuring his photos, and inspiring the public to learn about the Ocean Shore Railroad."

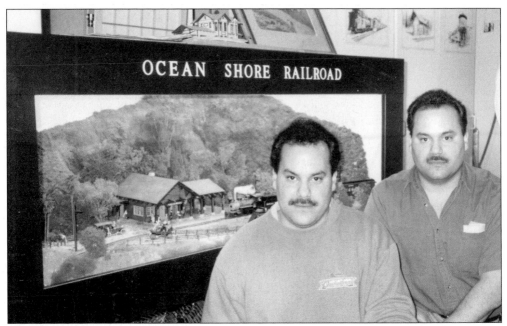

The Vargas brothers, Armando and Danilo, are twins with a passion for making accurate historical railroad models. Their enthusiasm for the Ocean Shore has done a lot to restore public awareness of this early railroad.

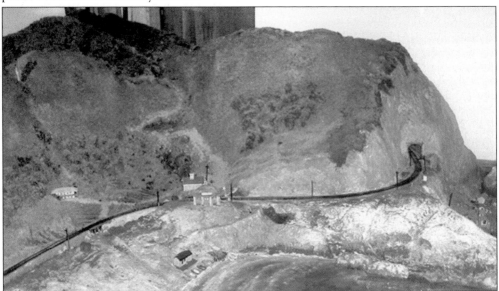

Danilo and Armando work as "Images of the Past Model Railroad Builders," recreating railroads in any scale and placing them anywhere from small rooms to large warehouses. "We specialize in building great model railroad empires for your enjoyment," they say. You can reach them in Tiburon, California, at (510) 334-0870. They requested that the following statement be included in this book about the Ocean Shore Railroad: "We would like to give special thanks to Chris Hunter for the dynamic person he is and not letting us down, and to our dear friends, Ted and Betty Wurm, for the trust they had in us. It takes the right person with the drive to get things done. Thank you, Chris, for never giving up and for making this book possible."

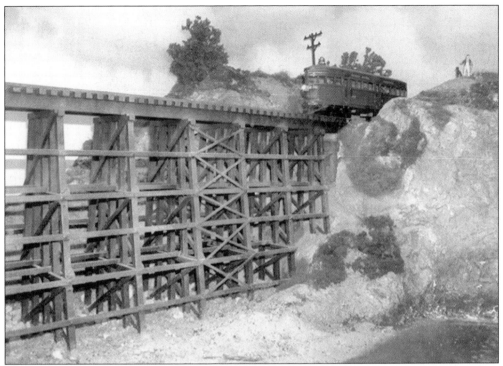

The Vargas brothers bring an astonishing level of detail to their model recreations of the Ocean Shore Railroad.

The Vargas brothers' whimsical recreation of the Ocean Shore Railroad helps bring the memory of the railroad to life.

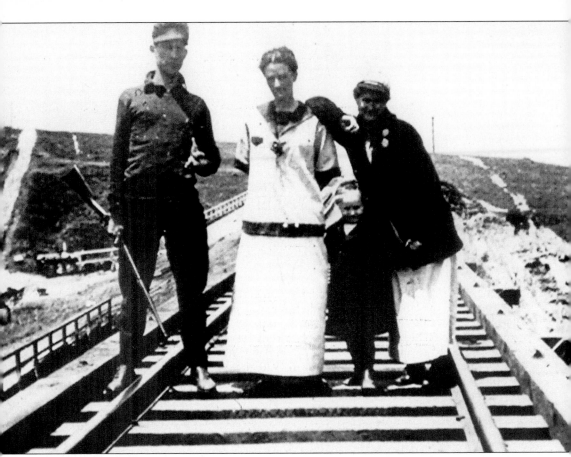

Ted Wurm, who died in 2004, once told the Vargas brothers: "Make sure that you guys give me credit for the book, because this is dear to me. My father worked for and loved the Ocean Shore Railroad and I am trusting you guys to get the book written. Don't let me down." Ted Wurm Sr. is the man on the left holding the gun. Thanks to Ted Wurm and others who have maintained personal and public fascination with the Ocean Shore Railroad. Because of people like them, the memory of the little railroad that "Reaches the Beaches" will never completely fade away.

THE MYSTERY OF
THE PEDRO POINT TUNNEL

The Ocean Shore Railroad drilled and blasted its tunnel through the western edge of San Pedro Mountain because the landscape there made it impossible to simply continue a ledge around the narrow Pedro Point. A remarkable feat in itself, as outlined earlier in this book, the construction of the 400-foot tunnel was simply part of the overall effort to lay tracks along the coastal bluffs and cliffs leading south to Half Moon Bay and Santa Cruz.

When the Ocean Shore ceased functioning in 1920, the tracks were torn up and the engines sold. But the tunnel itself continued to exist as a reminder of the grand railroad plans.

Unfortunately, or understandably, an abandoned tunnel on the San Mateo County coast, especially during the Prohibition years of the late 1920s, became a perfect hiding place for bootleg alcohol. With relatively safe mooring areas near Pedro Point and the beach at the foot of San Pedro Valley, it was fairly easy for pirates and rumrunners to stash cases of illegal alcohol in the abandoned tunnel. It became so commonplace and and such a well-known a hiding place that eventually federal agents, weary of battling bootleggers over the tunnel, simply blew up its two entrances, sealing forever the hiding place.

Folks growing up in the area remember clambering through tiny open spaces and telling stories about cases of treasure sealed within the tunnel. Whether that is true or not is unclear. There is no documentation of it being haunted or the site of entombed pirates or whiskey. The tunnel was most likely emptied before being sealed, but the stories continue to be told of the Pedro Point tunnel and its mysterious life after the Ocean Shore Railroad.